The Old Testament

The Old Testament

Through 100 Masterpieces of Art

Régis Debray

Introduction

Here is a remarkable paradox: the book that prohibits images has become a treasury of images, the great storehouse of them for the Western eye. The book recording the first ban on making and worshipping idols—on pain of death, the fate Moses decreed for the worshippers of the Golden Calf—has become our prime visual reference. The Koran's position is more indulgent than the Bible's, Islam's iconoclasm being based on the Hadith, the sayings of the prophet, which are not in the Koran itself. The Old Testament's prohibition comes directly from God. It is categorical, graven in stone on the original Tablets of the Law. Will we, who take pleasure in looking at what we should only read, eventually become polytheistic? Animists? Believers in or practitioners of magic? Falling into idolatry is one thing, but involving the most iconoclastic of holy texts in it is another thing altogether. For antiquity's first believers in a non-figurative God, the starting point was the rejection of simulacra. But in the modern era that very faith's sacred texts gave rise to the West's greatest body of visual art. This staggering metamorphosis deserves pondering.

The prophets told us that imagery is witchcraft, has dominion over things and spirits, belongs to the kingdom of magic, the powers of the night, to femininity and evil spells. Magic is the manipulation of occult forces by means

of material signs. Religion seeks not to constrain God (or gods) by mechanical means but to reconcile humankind to God through prayer leading to a personal relationship that, in principle, should not require the aid of inert things like painted or sculpted images. Monotheism seeks a practice of reading free of the slightest hint of idolatry. It suppresses the representative image latent in the verbal symbol. And idols are not only images of false gods but also false images of the truth, for the truth about God is infinite and incommensurable with any materiality of the sensuous world. The Invisible is legible but not figurable. The Word is potent, illustrations impotent. "You shall have no other gods before me. You shall not make yourself an idol, whether in the form of anything that is in heaven above or is in the earth beneath You shall not bow down to them or worship them." (Exodus 20: 3–5) An image is a minute thing in the universe, but God *contains* the universe. Images are heavy, and the man of the Old Testament begins as a nomad, a pilgrim, a wayfarer, never at rest. The prophets Samuel, Elijah, and Elisha are wanderers, unencumbered by altars, statues, or effigies. The prophets Isaiah and Jeremiah are pure voices.

Yet the effect of the Old Testament in the Christian West has been to overturn these prohibitions because the text tells a story, or rather, thousands of stories springing

up one after another. The Everlasting pronounces his commandments, sets the goals, and summons mankind to its duty. He intimidates. His people live through improbable successes and reversals of fortune, falling into the void and being restored to grace in stunning changes of scene. One story is moving, another riveting, yet another harrowing. True, the Everlasting can, and doubtless must, do without images (*Deus pingi non potest*), but where there is a story the imagination cannot be kept from functioning, giving faces to names, colors to places. A God without an image can seem remote, and religions that separate the creator from his creation are neither the tenderest nor the most indulgent to sinner, apostate, or unbeliever. God has only names, a tetragrammaton, indeed only a modest initial (*The Encyclopedia of Judaism* restricts itself to "G-".) He has no form, and when he appears to Old Testament prophets it is as a burning bush, a shapeless flame. In principle, to violate the prohibition against imagery was as grave a crime as to commit incest or murder. There is even a Talmudic treatise, the *Avodah Zarah*, that forbids a Jew to do business with an idolatrous Gentile before one of the latter's holy days lest the Gentile sacrifice his profit to his idol. Nonetheless, the Israelites worshipped the Golden Calf and built altars to Baal and Astarte. The Holy Ark bore carvings of the Seraphim. As

for the prohibition itself, would Moses have formulated it so strongly and so many prophets hammered it out so repeatedly if observing it had been a matter of course?

Ancient Israel was not alone in proscribing representation of the divine. Vedic Hinduism and early Buddhism equally prohibited it—and in the long run were equally unable to uphold the prohibition. Legend and the imagination overtook it with an extraordinary proliferation of painted and sculpted images. And Hebraic and Islamic aniconism were continuously disquieted by transgression, like sleep by fever. In Islam, there are Persian miniatures and the manuscripts of Koranic stories. The Hebrews were quite often tempted by the arts of fresco, mosaic, and manuscript illumination, as witnessed by the frescoes of the Syrian synagogue at Doura-Europos (albeit dating from the Hellenistic period). There are many Jewish and Islamic images in Andalusian Spain and Mogul India. Moreover, not all Old Testament stories fell under the ban on figurative imagery. The Sacrifice of Isaac could be represented because it seals God's Covenant with his people; so could an historical narrative like that of Esther, which does not mention the name of God and which gave rise to sixteenth-century illustrated scrolls. The Old Testament manuscripts of the fourteenth-century rabbi Moses Arragel are also illustrated (albeit for Christian readers), as is the

manuscript *Haggadah of Sarajevo*, which dates from the same century.

The Old Testament's personal visions and visionary narratives evoke more than words. God as such is, without a doubt, unrepresentable, but there is something in the divine of any culture that pushes irrepressibly toward the plastic. In Western culture, might not the idea of a physical manifestation of god but without images necessarily half-paralyze a visionary? One might say that God as the Supreme Being, all-powerful and omniscient, absolutely distinct from the created world, engages the believer's left brain—the conceptual side. But sooner or later the right brain, seat of the imagination, asserts its prerogatives. An illustrated Old Testament, then, more than honorably re-establishes equilibrium between the monotheist's two cerebral hemispheres. Cardinal Etchegaray, formerly Archbishop of Marseilles, authorized a comic-strip Bible and recently wrote a preface to it. It is difficult to imagine a prominent rabbi doing the same.

The most striking thing about Western painting's iconography of the Old Testament is how its character developed and progressed through time. It was Christian New Testament adherents who translated Old Testament *stories* into images for the whole world. But the work was a long time in coming.

From 285 to 246 B.C., seventy-two translators working in Alexandria gave the world its first Greek translation of the Aramaic Old Testament—the Septuagint Bible (after the Greek word for "seventy.") In the early Christian era, the First Council of Nicaea (325), the Council of Chalcedon (451), and the great Byzantine iconoclastic crises (beginning in 725) led to the Second Council of Nicaea (787), which made religious imagery based on the Scriptures possible and set the stage for its widespread propagation throughout Renaissance Italy and the West: the Septuagint's artistic child. But, for this long development to occur, Christianity first had to assert the existence of a thread leading from the first to the second Testament, and the assertion had to be widely accepted. Moreover, Christianity's traditional exclusion of the Jews (for example, its expulsion of them from various places for what was considered their blind refusal to recognize the Church as the legitimate daughter of the Synagogue) had to give way to a period of inclusion (in which, for example, the coming of Christ was construed as the fulfillment of God's covenant with Abraham). Christians claimed as their Old Testament the Hebraic texts called the Tanak (an acronym for the Old Testament's three great sections, the Law, the Prophets, and the Writings) and construed them as one long prelude to, or pre-publication of, the New Testament.

In this view, the story of fallen Job anticipates that of Christ of the humiliations; Ezekiel serves to prefigure St. John the Baptist; the prophet Isaiah is a Christian before Christianity and his verses not only resound with the blows that twice levelled the Temple but predict the Temple's replacement by the Body of Christ; and the lion lying down with the lamb, the swords beaten into plowshares, are a foretaste of Advent. With respect to legitimacy, these images are daughters of what one might call Christianity's "theology of recapitulation," according to which the New Testament sums up and gives birth to the truth of the Old and makes the implicit explicit. The Gospels *become* the fruit of which, metaphorically, the Pentateuch is the seed and the pictures the efflorescence. The paintings reproduced here are the flower.

Still, the blossoming required some daring. Although throughout the Middle Ages the Bible was copied on parchment and richly illuminated, it was during the Reformation and Counter-Reformation that images were allowed to flourish.

The Reformation's return to the Scriptures in opposition to Rome's monopoly of their interpretation led to a proliferation of woodcuts, engravings, and etchings of Old Testament stories, prints that achieved the cumulative effect of translating the Old Testament's verbal imagery

into pictorial images—the imagery of which equalled the original's in its concreteness and vividness, and in much of its variety. The Lutherans, albeit devoted to the Word, were more kindly disposed to visual imagery than the Calvinists and kept medieval statuary in the churches they took over from Catholicism, "because it had a visible tie with the Bible."

In the cosmopolitan city of early seventeenth-century Amsterdam, where all heresies rubbed shoulders, liberty of conscience met up with the wheat and spice trades to give free rein to the genius of both the Jewish philosopher Spinoza and the Christian painter Rembrandt. There, the Scriptures informed daily life from the humblest to the richest levels of society, and the Bible provided for all interpretations. It nourished the work of Rembrandt, who took up lodgings in the picturesque Jewish quarter of Breestradt. This painter of *Belshazzar's Feast* and *Samson and Delilah* erased the boundary between church and synagogue and in the warm light of his paintings joined the Hebrews of legend with the Jews on his street corners. With bold strokes and deep tones his brush reconciled the inner life with the divine plan.

With Rembrandt, the Scriptures penetrate to the innermost reaches of our beings and the boundaries between theology and everyday life disappear, so much

so that he ennobled his portrait of his friend, the rich merchant Jacob Trip, into a portrait of a doctor of the Talmud worthy of Babylon.

By contrast with the Islamic world, which dates true history by the Hegira of 631, Christian culture has retained an historical relationship with Greek and Hebrew precursor signs, incorporated into and extended by its Latin constructions. This culture has to preserve contact with the memory of a past event, the Passion of Christ. The mission of its sacraments is to abolish the distance that separates us from it.

In the period that saw the emergence and flowering of Christian religious painting, relics closed the distance between past and present, as did the Jews, considered then by Christianity as living witnesses of the time of Christ whose presence in Europe attested the historical reality of Jesus and the fact that he was indirectly present among European Christians. To Christians in the cities of Late Medieval and Renaissance Europe, the Jews were the Jerusalem of the past and their extraordinary antiquity pleaded for toleration. In the era in question, as for millennia before it, the old were more heeded than the young; the more ancient a piece of wisdom the stronger its credibility. In addition to its being divinely inspired, the Old Testament was, for most of the Christian era, "the

oldest book known"—and remained so until the day in 1872 when an English Assyriologist told the London Society of Biblical Archaeology that he had discovered a cuneiform account of the Flood older than that which we had known for all eternity. It was a tablet of the *Epic of Gilgamesh*, from the beginning of the second millennium before our era, and itself an excerpt from the *Poem of the Supersage*, from the third.

We may be entertained by ancient epics. But we are enthralled by books that *read* us—that tell us about ourselves and give us access to our own secrets. They are texts that last, and in which each forgetful generation can come to see itself as eternity changes it. Like the Koran for Islam and the *Bhagavadgita* for the Hindu world, the Old Testament is one of these mirror books. It can be read as a story of identity, for it narrates the dreams and tribulations of an exceptional people and, through them, the odyssey of a singular God who had many children. But this deeply picturesque text, with its story of a chosen people, has become a portmanteau for humanity's myths and phantasms. This unchanging history no longer discloses a folklore or ethnography but a syncretic classicism, the common repertoire of our legends.

Christianity's depictions of this primordial narrative attest a double phenomenon of appropriation and

expropriation. Each scene has become a parable and its local color the context of the sublime. In this context, the figure of the Jew is problematical. To the eye and in the art of every culture the "other" has its stereotypes, and a stereotypical Jew is often found in Western religious painting. In the period that produced the art in this volume, the Christian eye had no interest in what the Jewish people of the Old Testament era looked like and was unconcerned with placing them in a truly historical context. It bypasses the historical people of ancient Israel without shame but, rather, in perfectly good conscience; religious painting is less concerned with illustration or witnessing than with argument and demonstration. We are so used to this annexation of an Eastern narrative by a specifically Western and Christian culture that projects its codes and its preferences onto it that we are no longer curious about what it might have retained from the Old Testament. Neither do we ask whether that which *was* retained might not have seemed strange to the Old Testament's authors and its original audience. After all, to a Jew, *Boaz Asleep* is the much likelier theme for an allegorical painting than *Susanna and the Elders*, but we have very few Christian paintings of Boaz and scores of Susanna. Also, Christian iconography gives prominent place to Old Testament women. It undeniably prefers

Bathsheba and Esther to Ezra, Jeremiah, and Elijah. These wayward women and high-born beauties combine the sacred and the profane, legitimacy and sensuality. They have much greater dramatic appeal, and *have been given* a stronger figurative rendering than the austere prophets. And Jacob's Ladder has become, in part, a Christian figurative theme.

Until the nineteenth century the artistic professions were closed to Jews. The emergence of Jewish painters and printmakers lagged somewhat behind that of Jewish musicians like Offenbach and Halévy, who, in Germany, were the first to step out of the synagogue's shadow. It was not until the end of the nineteenth century that Jewish plastic artists emerged. Just as Rembrandt transposed Daniel into the realm of Christian painting, Marc Chagall appropriated the symbol of the Cross for a Jewish theme, removing Christ from it and putting the figure of the Hebrew on it instead.

The realms of suffering, desire, and hope are common to oppressed people the world over, regardless of race or religion. It is in part because of these grand and universal themes of humanity that religious art still refreshes the contemporary gaze. But so does the pictorial language of the pictures here. In our era, when Impressionism's shimmer and even Pointillism's evanescence have been

replaced by the detailed verisimilitude of the photographic lens, and when the cinema's and television's close-ups and fast cutting have decomposed the scene into fragments and rapidly disappearing details, the "archaic" practice of the fourteenth- to nineteenth-century painters represented by this volume reminds us of the sheer visual power that lies in the subordination of detail to the whole, in the large perspective, in frankly theatrical framing. In short, it restores composition to an age that has lost touch with it.

But above all, independently of religious convictions, in a time that seems to care much about form and little about content, Old Testament themes enable us to taste and to meditate on figures of universal humanity through the contemplation of images based on monotheistic legend. And, independent of the viewer's beliefs, no painting can be considered a masterpiece that does not in some way promote a meditation on our common humanity.

In the pages of this little book the reader will find a wealth of visual narrative. Each picture represents a story or an episode that has inspired many artists and so has been interpreted and reinterpreted in myriad ways throughout the history of art. Each picture has its dramatic autonomy. Its still imagery combines to illustrate a particular moment and can awaken in the reader a thousand lost dreams. And when one passes from one episode to another, page after page, a sense

of movement takes over, the legend of the centuries seems to unfold before one's eyes in a visually lyrical mnemonic précis of the human condition, seen from a pisgah view of historical perspective, or as in a rapidly moving film. David and Jonathan ... the Suicide of Saul ... the reign of David ... the splendor of Solomon's Temple ... the turbulent times of Elijah and Elisha ... the Babylonian Captivity, with Esther and Mordecai ... Susanna and the Elders For readers wishing to gain further knowledge or engage in further interpretations, this book does not replace a reading of the original texts or contemplation of the original paintings. Nonetheless, as a gallery of stories and images, it may serve as an introduction to or a reminder of Western culture's founding narrative and, perhaps, revive in our collective memory the poetry and power of ancient stories and past visual art, both of which are threatened with extinction by the sterile images and jejune stories offered daily by contemporary culture.

The Creation of the World

In Genesis, the creation of the world takes place over six days. Before creation itself, God had called heaven and earth into being, but all was in chaos and, "a wind from God swept over the face of the waters."

Hieronymus Bosch
c. 1450–1516

The Creation of the World

Prado
Madrid

THE FIRST DAY

God separates light from darkness, "and there was evening and there was morning."

THE SECOND DAY

God creates a dome, which divides "the waters that were under the dome from the waters that were above the dome."

THE THIRD DAY

God separates the land and the seas, and "earth brought forth vegetation."

THE FOURTH DAY

The creation of the sun, moon, and stars.

THE FIFTH DAY

The creation of fish and birds.

THE SIXTH DAY

The creation of land animals and of man.

THE SEVENTH DAY

God rests.

Most frequently depicted are the fifth and sixth days, in particular the creation of the animals. This theme gave painters an opportunity to depict many different animals, which added variety of form, line, color, and—especially—action to what is essentially a static subject, and to unite a moment in the remote past with the painter's and his audience's era.

In the Sistine Chapel, five out of Michaelangelo's nine frescoes are of the Creation.

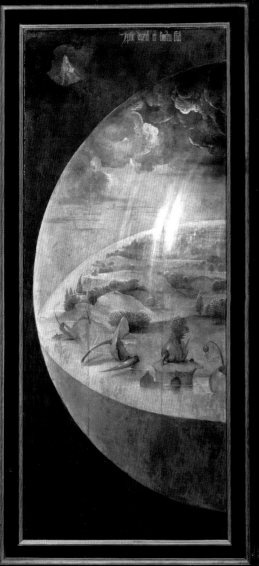
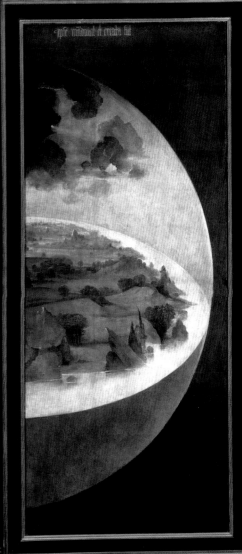

The Earthly Paradise

"And the Lord God planted a garden, in Eden, in the east." Genesis adds that "a river flows out of Eden to water" the earthly paradise, then divides into four branches, the Tigris, the Euphrates, the Pishon, and the Gihon.

Commentators have identified the Pishon with the Arabian peninsula, and the Gihon with the Horn of Africa and the River Indus. Perhaps Genesis confused these rivers with oceans, but Old Testament geography remains approximate. As for topography, the imaginations of Western painters made it primarily and specifically European, but variously so, as each filled the Garden with plants, trees, and flowers he knew. But as painters' "knowledge" of the world always comes in part from pictures, the Gardens of some Western European paintings have exotic vegetation unknown to painters except through pictures.

Depending on the moment of creation a painter depicts—his "invention," as the Renaissance termed the specific moment of a biblical or historical story that a painter depicted—the garden has only plants or both plants and animals. There the lamb lies peacefully down by the lion, and Adam and Eve quietly converse, sometimes with God.

One precise topographical detail provided by the Scriptures is sometimes depicted: the presence, at the garden's exact center, of the tree of life, symbolizing the promise of immortality, and the tree of the knowledge of good and evil, whose fruit, in the seventeenth-century English poet John Milton's words, "Brought death into the world, and all our woe."

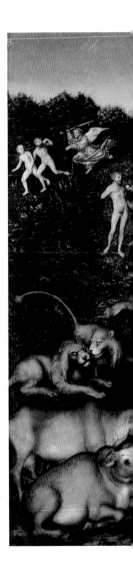

Lucas Cranach the Elder

1472–1553

Paradise

Gemäldegalerie, Alte Meister
Dresden
Germany

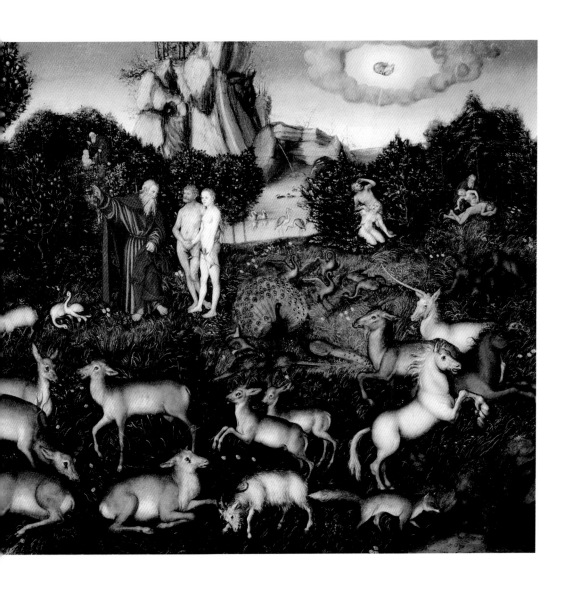

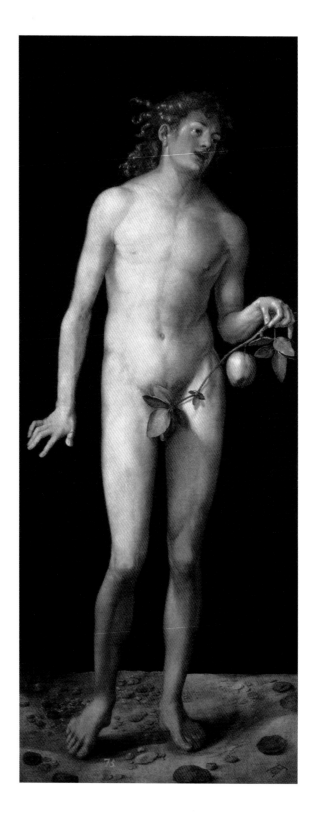

The Creation of Adam

Albrecht Dürer

1471–1528

Adam

Prado
Madrid

"God said, 'Let us make humankind in our image, according to our likeness … .' Then the Lord God formed man from the dust of the ground, and breathed into his nostrils the breath of life, and the man became a living being."

By way of reciprocity, God's words came to authorize the representation of God in man's image. And because artists take "man's image" both from life and from prior art, Genesis's extremely brief account of the creation of man has given rise to an abundantly diverse iconography with respect to the depiction of God. For instance, after Renaissance Italy's rediscovery of Ancient Greek and Roman art came images created by Renaissance painters of God the Father as a bearded, muscular man in the prime of life, after ancient Greek statues (and Roman copies of them) of Olympian Zeus.

Similarly, the Western image of Adam came in part from prior art. The pose of Dürer's *Adam* can be traced back to that of the *kouros*, archaic Greek sculpture's motif of the beautiful young man. And images of Adam in turn helped establish Western painting's canon of masculine beauty.

The Naming of the Animals

After God created Adam in the Garden of Eden he created the animals, who provided Adam with companionship and help. Then God wanted "to see what he would call them," and the task of naming them fell to Adam.

Paintings of "the cattle, and ... the birds of the air, and ... every animal of the field" filing before Adam to receive their names often contain images of non-European animals, such as monkeys, lions, and elephants, together with images of unicorns and other animals of fable, attesting painters' zoological knowledge of their own world, their familiarity with animal paintings from other cultures, and the survival into the early scientific age of ancient beliefs in animals of myth and legend.

Master Bertram von Minden
c. 1345–1414/15

The Creation of the Animals

Kunsthalle
Hamburg
Germany

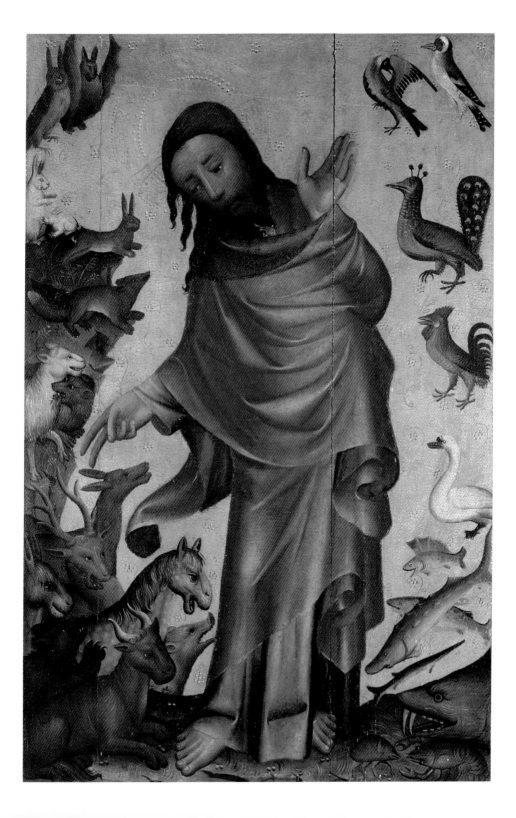

The Creation of Eve

The Scriptures' first mention of the creation of our species says that "God created humankind … male and female he created them"—in other words, Adam and Eve at the same time.

But Christian iconography follows the Bible's second account: "The Lord God caused a deep sleep to fall upon the man, and he slept; then he took one of his ribs and closed up its place with flesh. And the rib that the Lord God had taken from the man he made into a woman and brought her to the man."

God raising Eve out of the sleeping Adam's side was a favorite theme from the time of the medieval miniaturists up through the Renaissance, but gradually lost popularity in the era of oil painting.

Tradition is ambiguous. Some commentators argue that Eve's creation at a later time than Adam's is an indication of woman's inferiority. But Adam calls Eve "flesh of my flesh," which implies an equal relationship between the sexes.

Anonymous, Antwerp
c. 1530

The Creation of Eve

Musée St-Denis
Reims
France

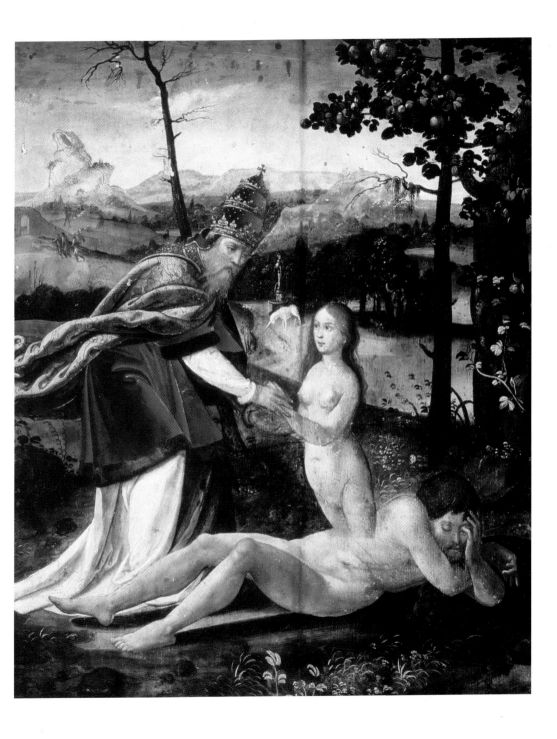

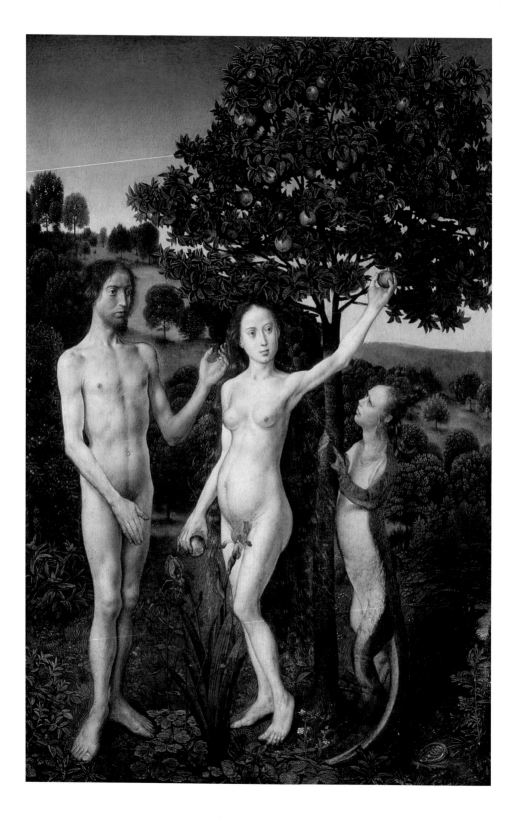

The Temptation

Hugo van der Goes
c. 1440–1482

The Fall from Grace

Kunsthistorisches Museum
Vienna

Tempted by the serpent, Eve eats the forbidden fruit of the tree of knowledge of good and evil, then persuades Adam to eat it too.

"Then the eyes of both were opened, and they knew that they were naked." They made loincloths out of leaves and hid themselves from the sight of God.

The theme, depicted thousands of times, has become strictly codified: Eve must be naked, the serpent be close by the tree, and so on. However, there are infinite variations. For instance, the tree is most often an apple tree but it is sometimes an orange tree and in a twelfth-century fresco it is the poisonous mushroom *Amanita muscaria*. As the Scriptures do not describe the serpent, and as it was only after the Fall that God condemned it to creep along the ground and eat dust, painters have been free to give it a variety of forms and attributes. It was not the Scriptures but tradition and artists' imaginations that gradually gave the serpent the feminine traits and personality seen in Hugo van der Goes's painting shown here and in so many other paintings from the fifteenth through the seventeenth century.

When painters represented the immediate consequences of the original sin, they expressed Adam and Eve's awareness of their nakedness in images of a man and a woman veiling their genitals with their hands (Eve's gesture sometimes taken from the motif of ancient Greek statuary known as the *Venus pudica*), or concealing themselves deep in the underbrush in their futile effort to elude the gaze of a watchful God.

The Expulsion from Eden

Dressed in animal-skin tunics of God's own making, a woebegone Adam and Eve leave the Garden of Eden, which from now on will be guarded by cherubim and the flame from a twisted sword. Henceforth humankind is mortal ("you are dust and to dust you shall return"); woman will give birth in pain and man will get his bread by the sweat of his brow.

Some Western paintings show the actual event, with Adam and Eve just outside the earthly paradise as angels descend and take up their eternal post barring the way to the tree of knowledge. Adam and Eve, almost always clothed, seem overwhelmed by the punishment, and the landscape that awaits them east of Eden is egregiously less inviting than the Garden they leave behind. Other paintings are of their new condition in the fallen world—Adam tilling the soil, Eve giving birth or nursing a child—with settings and details reflecting the landscapes and life of the painters' respective countries and eras.

John Milton is rare among artists in any medium for his vision of the moment Adam and Eve step away from the Garden as one of calm, resignation, and hope. In the very last lines of his epic poem *Paradise Lost*, Adam and Eve turn one last time from Paradise and face the world below on Eden's eastern plain:

> Some natural tears they dropped, but wiped them soon;
> The World was all before them, where to choose
> Their place of rest, and Providence their guide:
> They, hand in hand, with wandering steps and slow,
> Through Eden took their solitary way.

Cavaliere d'Arpino
(Giuseppe Cesari)
1568–1640

The Expulsion from Paradise

Louvre
Paris

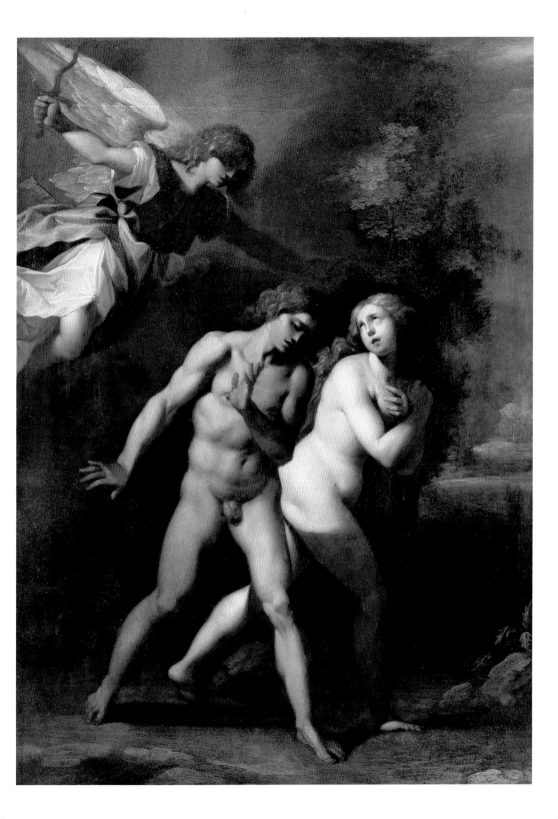

Angels and Archangels

The Scriptures abound with these servants of God, intermediaries between heaven and earth, between God and humankind. However, only three have enjoyed distinct personalities: the Old Testament's three archangels accepted by Christian tradition.

St. Michael is the warrior angel, who combats the devil and will triumph over him at the end of time. At several points in the Old Testament he fights alongside the Hebrews against their enemies.

St. Gabriel is the messenger angel, who interprets Daniel's dream for him as a vision of Israel's future salvation, the end of the world, and the coming of the kingdom of God.

St. Raphael is the companion angel, who aids and supports Old Testament heroes in their times of trial. In paintings he is often seen at the side of Tobias, as in Francesco Botticini's painting here.

Although tradition does not name the other angels it does arrange them in a three-tiered hierarchy, each tier divided into three choirs, each choir with its own attributes. Thus we find the Cherubim, Seraphim, and Thrones; the Dominions, Virtues, and Powers, and the Principalities, Archangels, and Angels.

Some categories are further refined, with distinct appearances attributed to certain types. In the first tier, the Cherubim, who watch at the gates of the Garden of Eden, are given four wings and four faces (of a lion, an eagle, a man, and a bull), while the Seraphim have six wings. These distinctions appear in certain paintings, but in most paintings, the angels and cherubs, whose functions are largely decorative, are mostly interchangeable.

Francesco Botticini
1446–1498

The Three Archangels and the Young Tobias

Uffizi
Florence
Italy

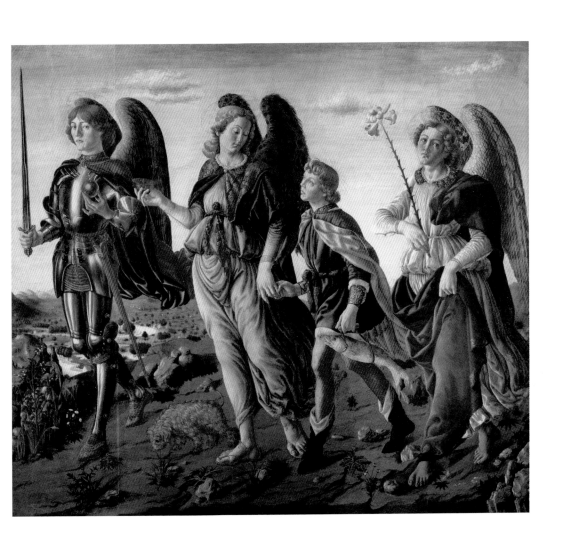

The Fall of the Rebel Angels

According to the Scriptures, a mighty event took place before the creation of the world: the revolt of the bad angels.

Led by Satan, a number of angels committed the sin of pride and rebelled against God. The story has come down to us in its present form from the final book of the New Testament, the Apocalypse, or Revelation, by St. John.

"And war broke out in heaven … . Michael and his angels fought against the dragon … . The great dragon was thrown down, that ancient serpent, who is called the Devil and Satan … he was thrown down to the earth, and his angels were thrown down with him."

Put to flight by the archangel St. Michael, they were plunged into the darkness of which Satan became Prince.

Although the rebellion is not mentioned in the Old Testament, as it took place before the moment in divine history at which Genesis begins, tradition has integrated the War in Heaven with Genesis as a sort of founding event.

Innumerable painters treated this theme in the sixteenth through the eighteenth century. Among the major motifs are heaven and the darkness below, the combat between the good and bad angels, and Satan's fall. Sometimes the physical and symbolic transformation of Lucifer ("Morning Star") into the devil Satan ("Enemy of God") is expressed by a figure of the shining Seraphim sprouting bat's wings as he passes from brightness to darkness.

Luca Giordano
1634–1705

The Archangel Michael Hurls the Rebellious Angels into the Abyss

Kunsthistorisches Museum
Vienna

34

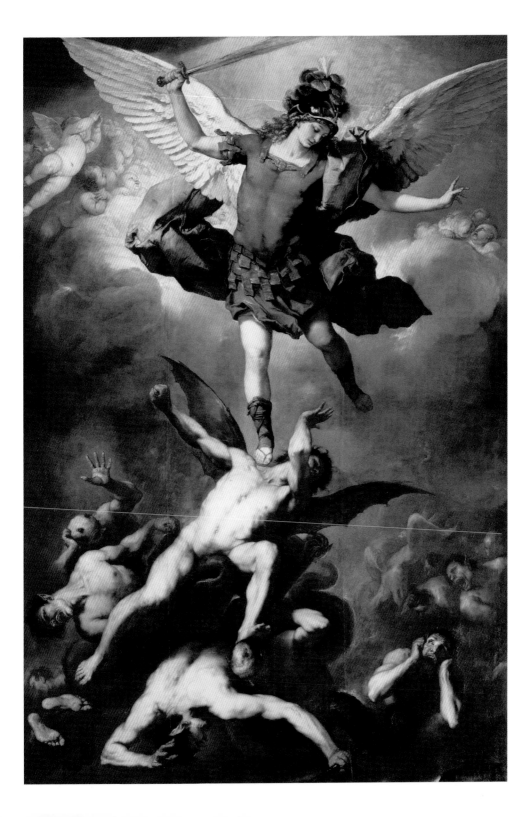

Cain and Abel

Adam and Eve had two sons. Cain, the elder, became a farmer; Abel became a shepherd. The conflict between settled tillers of the soil and nomads was born.

Both sacrificed the fruits of their labor to God, Cain the first fruits of his harvest, Abel the first born of his flock. But at a certain point, God accepted Abel's sacrifices and rejected Cain's. Deeply angry, Cain led Abel into the fields and struck him dead.

"Then the Lord said to Cain, 'Where is your brother Abel?' He said, 'I do not know, am I my brother's keeper?'"

To punish him, God commanded Cain to cease farming. "When you till the ground, it will no longer yield you its strength."

Cain was doomed to perpetual nomadism. Six generations later, three brothers among his descendants—Jubal, the shepherd, Tubal, the forefather of musicians of the fairs and marketplaces, and Tubal Cain, the first to practice the originally itinerant trade of blacksmithing— became emblematic of his fate and perpetuated it in turn for their descendants.

Beginning with Renaissance painting, in which, as the twentieth-century painter Willem de Kooning put it, "Everything was gesture The people were doing something; they looked, they talked to one another, they listened to one another, they buried someone, crucified someone else," painters of the Cain and Abel story concentrated on the murder. But the Romantic era saw a shift in emphasis from the act to Cain's feelings. "Cain is a proud man," Byron wrote of the raging hero of his verse drama *Cain* (1821). Victor Hugo's poem "Conscience" (1853) concentrates on Cain's remorse and repentance. And late-Romantic painters tended to treat Cain's guilt and wanderings rather than his murder of his brother.

Titian
(Tiziano Vecellio)
c. 1485/90–1576

Cain and Abel

Santa Maria della Salute
Venice
Italy

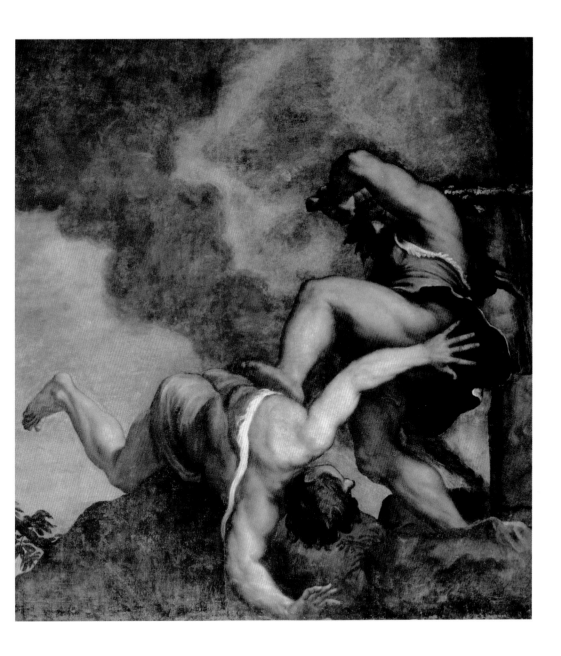

The Flood

Pondering man's wickedness, God regretted having created him. He decided to eliminate him and the animals from the face of the earth by drowning them in the seas. And so all flesh, everything that breathes on earth, men, beasts, and birds perished, with the sole exception of Noah and the contents of his ark.

The account of this end to the world takes up only a few lines of the Bible but it has inspired innumerable works. With their rains, rising waters, and scenes of panic and drowning, these dramatic and turbulent paintings seem intended to invoke the awe that impels the wayward back toward the path of righteousness.

Ivan Konstantinovich Ayvazovsky
1817–1900

The Flood

Russian Museum
St. Petersburg
Russia

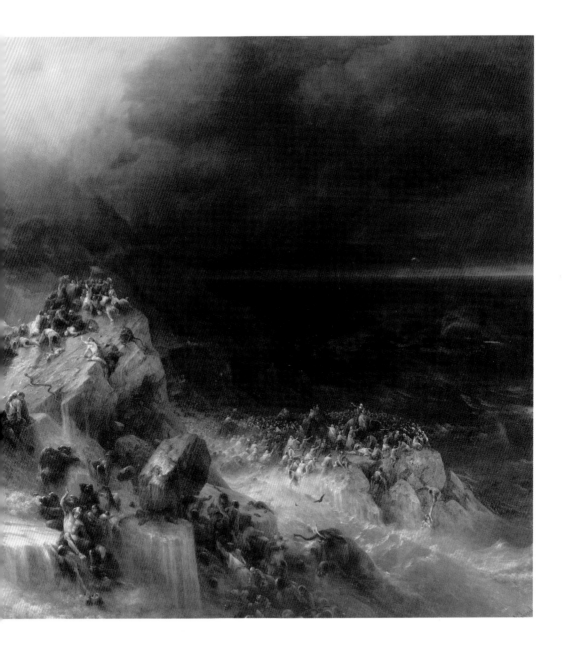

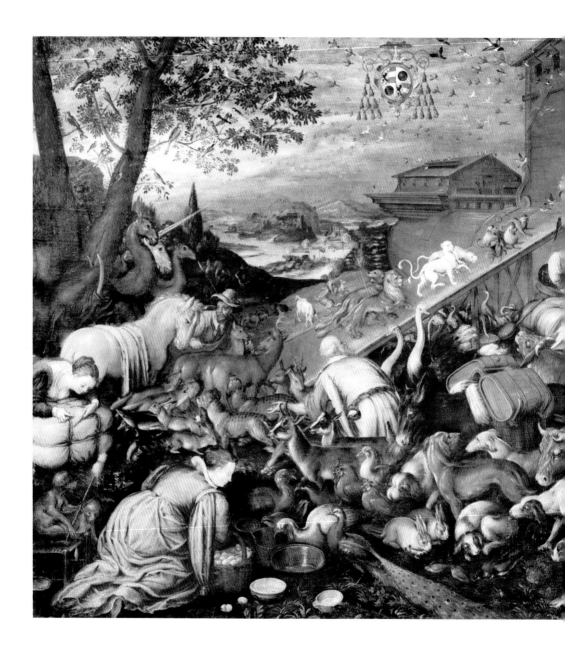

Noah's Ark

At the time of the Flood the six-hundred-year-old patriarch Noah and his family found favor in the eyes of God, who commanded him to build a huge ark and take into it one male and one female of every species of animal—clean and unclean, those that fly, walk, and crawl. Made of cypress wood and coated with bitumen, the ark was three hundred cubits long (about 430 feet). When Noah, his family, and the animals were aboard, God let the waters fall from the sky.

It rained for forty days and the waters rose to fifteen cubits higher than the highest mountains. Then the ark drifted for one hundred fifty days before coming to ground on the peak of Mount Ararat (in the Armenian plateau of today's eastern Turkey). Three months later Noah released a crow from the ark, but it returned, having found nowhere else to alight. He next tried the experiment with a dove, but with no more success. Seven days later the dove was released again and came back with an olive branch in its beak. After several more weeks the earth was dry. The Flood and its aftermath lasted a year and ten days.

Painters have treated all aspects of this story and have been particularly drawn to the boarding of the ark, an occasion for the demonstration of a painter's virtuosity in the drawing of both the human figure and the figures of domestic and exotic animals, and consequently provided rich and varied pleasure to the viewer.

The dove with the olive branch became a symbol of good news, then, by extension, of a message of peace, which is how we know it today.

Kaspar Memberger
c. 1555–1618

The Embarkation of the Animals into the Ark

Residenzgalerie
Salzburg
Austria

The Tower of Babel

Several generations after the Flood, all of Noah's descendants were still living together and spoke the same language. Aware that in unity is strength, they said to each other, "Come, let us build a city, and a tower with its top in the heavens, and let us make a name for ourselves; otherwise we shall be scattered abroad upon the face of the earth."

"Nothing that they propose to do will now be impossible for them," reflected God. "Come, let us go down and confuse their language there, so that they will not understand one another's speech." Then he scattered them. Owing to a wordplay in Hebrew, the unfinished Tower of Babel is also known as "The Tower of Confusion."

The notion of a language common to all men in the remote past re-emerged in the early twentieth century when some linguists claimed to have detected the basis of an original language, "Nostratic," from which all others derived. These linguists follow in the footsteps of the seventeenth-century Swede Andre Kempe, who enjoyed a certain notoriety for having proved that God spoke in Swedish to Adam, who replied in Danish, and that the serpent tempted Eve in French.

Pieter Bruegel the Elder
c. 1525/30–1569

The Tower of Babel

Kunsthistorisches Museum
Vienna

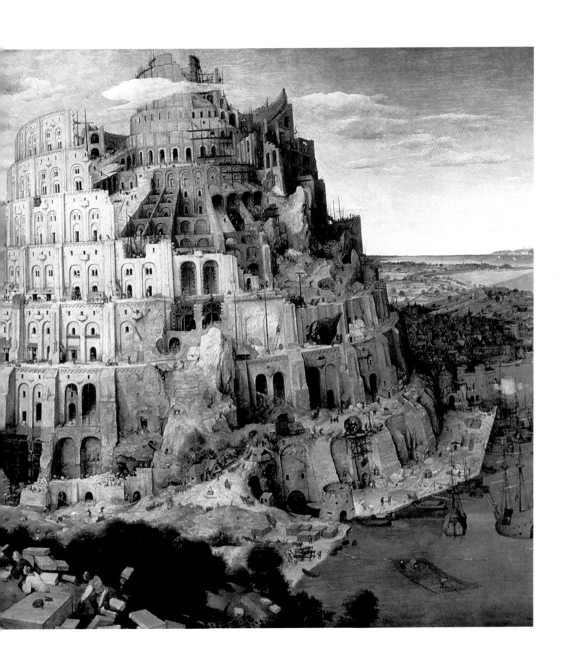

Abram in Egypt

The Old Testament's account of the transition from paganism to monotheism and the origins of the Jewish people begins with God's calling of a Chaldean pagan named Abram, a descendant of Noah born nine generations after the Flood. We know him as Abraham, the founding patriarch of the Jewish people. But he became a patriarch and the Jews as a people came into being only *after* the calling, when God established a Covenant with Abram. And God changed Abram's name to Abraham and his wife Sarai's to Sarah only after he renewed the Covenant with him several years later and promised him a son.

After God's calling, Abram left his home in the city of Ur (now in Iraq) for the land of Canaan (today's Israel). When famine struck Canaan he went to Egypt. There he passed off Sarai as his sister and she was taken as a mistress by Pharaoh, who showered Abram with gifts. (Abram told only half a lie: Sarai was actually his half-sister.) This illicit love affair brought sorrow and sickness to Egypt's sovereign and his house. Discovering the truth about Abram's and Sarai's bond, he sent them back to the Negev desert, from which they had come.

Although some Christian artists have been inspired by the event's earthly themes, most have expressed it as Christianity interpreted it, as an Old Testament prefiguration of Mary and Joseph's flight into Egypt with the infant Jesus.

Antonio Zanchi
1631–1722

Abraham Teaches Astronomy to the Egpytians

Santa Maria Zobenigo
Venice
Italy

Abram and Melchizedek

After being expelled from Egypt, Abram and his nephew Lot settled in the region of Bethel. But because there was insufficient pasture land for both their herds, they agreed to separate. Abram went toward Canaan, promised him by God, and Lot went to the fertile plains in the valley of the River Jordan and settled near the high cities of Sodom and Gomorrah.

During a war between an alliance of Eastern kings and the kings of the Jordan plains, Lot and his family were captured and taken north. Abram raised an army of three hundred eighteen men, pursued the captors as far as Hobah, north of Damascus, rescued Lot, and seized considerable plunder.

Returning to Canaan, Abram was met by Melchizedek, by whose dual status as king of Salem, then part of Jerusalem, and priest of "God Most High," the incident attests the existence of the One God and Jerusalem's symbolic significance.

Melchizedek shared bread and wine with Abram, and blessed him, saying, "Blessed be Abram by God Most High, Maker of heaven and earth; and blessed be God Most High, who has delivered your enemies into your hand!"

Abram gave Melchizedek his tithes, that is, one tenth of the spoils, thus recognizing both the religious status of this priest-king and the symbolic importance of Jerusalem.

Although the *mythography* of the incident itself points to an early propagation of Hebrew monotheism beyond the sphere of Abram, his family, and his immediate followers, Christians were bound to construe Melchizedek's sharing bread and wine with Abram as a prefiguration of Christ's sharing bread and wine with his disciples, which instituted the Eucharist. And so the *iconography* of Western Christian paintings tends to express the scene as a prefiguration of the Last Supper.

Peter Paul Rubens

1577–1640

Abraham and Melchizedek

Musée des Beaux-Arts
Caen
France

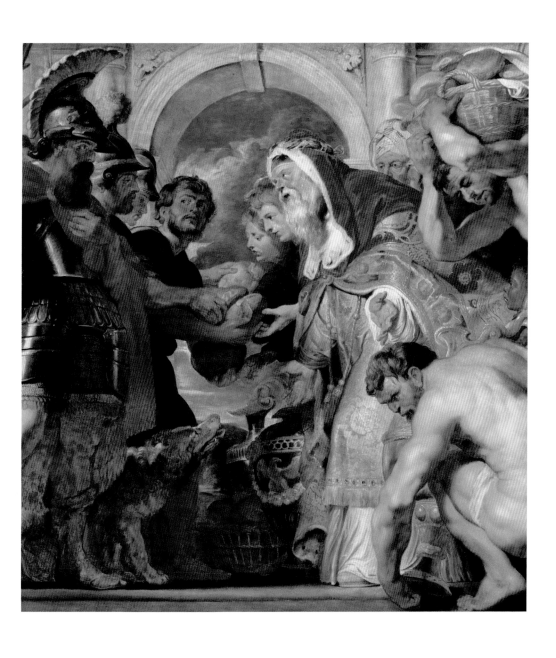

The Oaks of Mamre

After parting with Lot, Abram settled in the hill country around Hebron, near a place known as the Oaks of Mamre.

Sitting by his tent one evening, he was visited by "three men" who were really God himself and two of his angels. The Most High had already established his Covenant with the patriarch, who had had his whole family and his host of followers circumcised. It was at this time that God also changed Abram and Sarai's names to Abraham and Sarah. However, the fact that Abraham had no legitimate offspring caused him to live in doubt with respect to God's promise of innumerable descendants who would rule the land of Canaan.

On this day, God said to Abraham, "I will surely return to you in due season, and your wife Sarah shall have a son."

Sarah, listening at the entrance to the tent, laughed to herself in disbelief, knowing that at ninety years of age she was too old to have children, and that her husband himself was a hundred.

This promise made to Abraham is also important for the spot where it takes place: the Oaks of Mamre is near Hebron, the city where Abraham is buried and where, today, the conflict between the Jews and the Palestinians is crystalized.

Christians, however, focus on the "three men," whom the Bible cloaks in ambiguity. Three men? Or three angels? Certain interpreters even wish to see here the first appearance of the Holy Trinity. These are but some of the diverse interpretations that one finds in paintings of this instance of God's appearance to Abraham.

Giovanni Battista Tiepolo
1696–1770

The Three Angels with Abraham

Scuola Grande di San Rocco
Venice
Italy

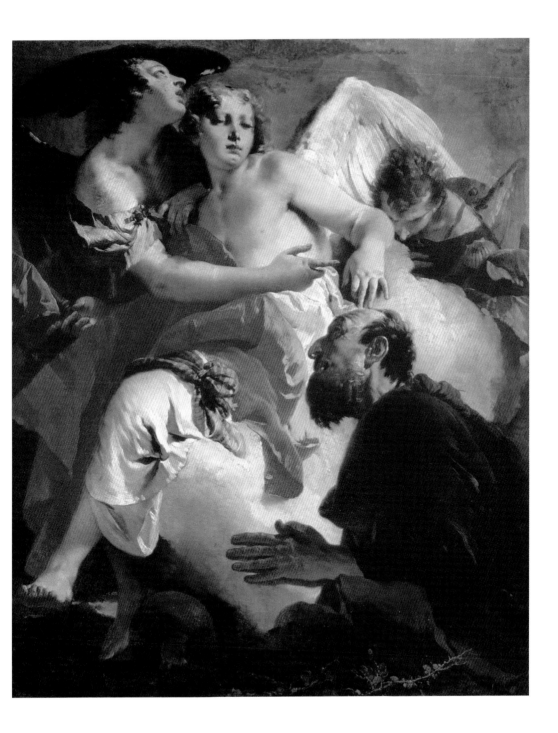

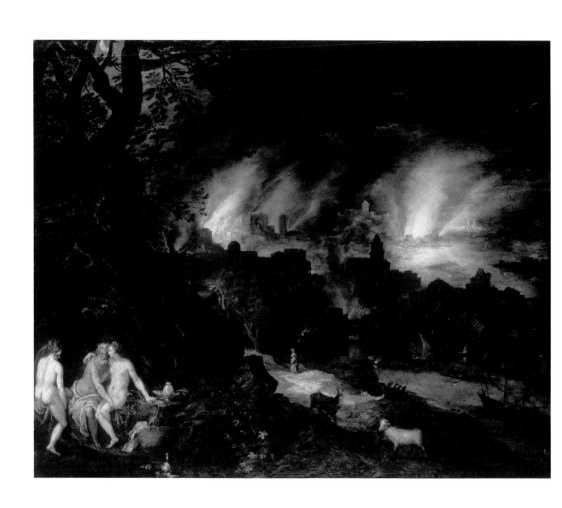

Sodom and Gomorrah

Jan Breughel 1
(called Velvet Breughel)
1568–1625

Sodom and Gomorrah

Alte Pinakothek
Munich
Germany

After promising Abraham and Sarah a son, God and the two angels left the Oaks of Mamre to travel on to the plains of Jordan, seat of Sodom, Lot's home, and the neighboring Gomorrah. An outcry had arisen against the extreme wickedness of both cities and God had decided to destroy them if it were true. But God turned back to ask Abraham's advice. In the ensuing momentous exchange, Abraham advocates the forgiveness of the sinful many for the sake of a righteous few, and God agrees to spare Sodom and Gomorrah for the sake of no fewer than ten righteous men.

In Sodom, the angels found only one righteous man, Lot. God commanded them to tell him to alert his family and leave before dawn. Lot also alerted his two daughters' future husbands. When the young men scoffed at him, he left with his wife and daughters, obeying the divine command to "Flee for your life; do not look back or stop anywhere in the Plain; flee to the hills, or else you will be consumed."

He had barely left the city when fire and brimstone demolished the cities of the plain. Lot's wife turned to look at the conflagration and was instantly turned into a pillar of salt.

Lot and his daughters fled on alone.

The seventeenth-century English poet George Herbert harked back in a poem to Old Testament times, when, he imagined, crises of faith, bloody conflict, catastrophes, and tragedies were tempered by God's direct contact with humankind. He evokes not only the Sodom and Gomorrah episode but also many others before and after it:

Sweet were the days when thou didst lodge with Lot,
Struggle with Jacob, sit down with Gideon,
Advise with Abraham …
One might have sought and found thee presently
At some fair oak, or bush, or cave, or well … .

Abraham Casts out Hagar

Before Sarah conceived, Abraham had fathered the boy Ishmael with his Egyptian slave Hagar.

Genesis indicates that as soon as she was pregnant, Hagar no longer had anything but contempt for the barren Sarah.

Sarah tolerated the situation as long as she was childless, but after the birth of Isaac, the son of her and Abraham's old age, she importuned Abraham to banish Hagar and Ishmael. "For the son of this slave woman shall not inherit along with my son Isaac."

The Bible states clearly that Abraham resisted her at first. Only when God said, "Do as she tells you, for it is through Isaac that offspring shall be named for you," did he acquiesce to Sarah's demand. God further reassured Abraham by telling him that Ishmael as well would found a great nation.

Early the next morning, Abraham gave Hagar bread and a skin of water and sent her and Ishmael into the desert. Jewish tradition justifies the banishment by stating that Ishmael "persecuted" Isaac. This interpretation came into Christian tradition through St. Paul. The Prado in Madrid has a painting based upon it by Luca Giordano.

This biblical account of the birth of the Jewish and Arab peoples, who trace their origins back to Isaac and Ishmael respectively, still resonates in mid-Eastern politics. But even before its modern-day consequences, it has, by its dramatic force, inspired painters, especially during the mid-nineteenth century's fascination with the Orient.

Lucas Engebrechtsz.
1495–1552

The Repudiation of Hagar

Kunsthistorisches Museum
Vienna

Hagar in the Desert

Cast out into the desert, Abraham's and Sarah's slave Hagar and her young son Ishmael wandered until the skin of water Abraham had given them was empty.

Hagar placed Ishmael under a bush and went away, saying, "Do not let me look on the death of the child." Hearing Ishmael cry, God sent an angel to Hagar to say, "Come, lift up the boy and hold him fast with your hand, for I will make a great nation of him." And as she opened her eyes, he showed her a well.

In this desert along the border between Sinai and Arabia, the young Ishmael became "an expert with the bow" and his mother found him an Egyptian wife. Thus is explained the origin of the Bedouins who are still present in the region.

The meeting between the mother and the angel, while the child lies beneath the bush, has provided a theme for European artists again and again. The title of Giuseppe Zais's *Landscape with Hagar and Ishmael* is indicative of a type of landscape painting with a few small figures that painters often chose for the depiction of biblical scenes, especially for those in which there is little action or drama. The moment itself is clearly described and its intensity is proportionately expressed with respect to the Scriptural account, but neither the event, nor the figures, nor their emotions fill the scene or affect the peacefullness and the promise of the nearby landscape awaiting Hagar and her son just beyond the desert's edge. Thus, in his handling of the landscape itself, Zais has expressed the Old Testament story's happy conclusion. And with the city in the far background, perhaps he has expressed the establishment of Ishmael's future lineage.

Giuseppe Zais
1709–1781

*Landscape with Hagar
and Ishmael*

Accademia
Venice
Italy

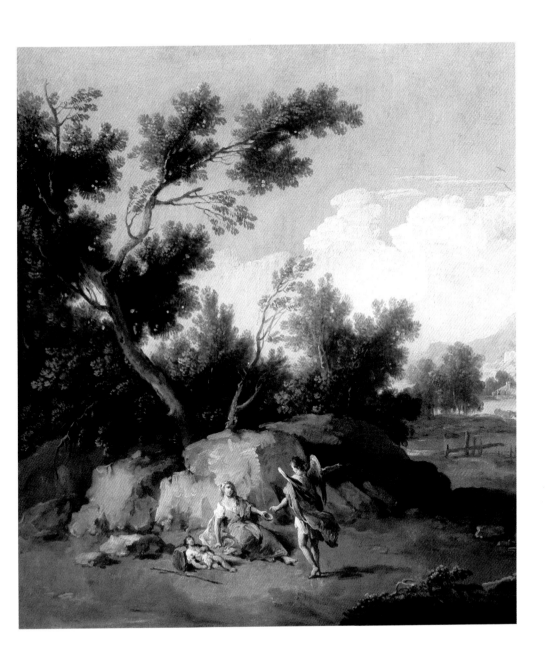

The Sacrifice of Isaac

To test Abraham's faith, God demanded that he sacrifice his son Isaac. Without hesitation, Abraham loaded the wood for the sacrifice onto Isaac's back, took the knife and sacrificial fire, and set out with his son for the land of Moriah and the mountain God would designate for the sacrifice. To Isaac, surprised at the absence of a sacrificial beast, he said only "God himself will provide."

On the mountain, Abraham built an altar, tied Isaac to it, and took out the knife. It was at that moment that an angel called to him and told him to stop. A wild ram tangled in a thicket was substituted for the boy, and God promised his servant Abraham descendants as numerous as the stars and the sands of the sea as a reward for his self-abnegation.

Thus the Scriptures ended human sacrifice, while affirming that the first-born should be consecrated to God.

Fifteenth-century Florence held a competition among seven sculptors, including Ghiberti, Brunelleschi, and Donatello, for the realization of the theme on the doors of the city's Baptistry. Indeed, few Old Testament themes have inspired European art as much.

Christianity traditionally construes the story as a prefiguration of Christ's sacrifice on the Cross. But the nineteenth-century Christian philosopher Søren Kierkegaard emphasized Abraham's faith. "Who gave strength to Abraham's arm?" Kierkegaard cries. "Who held his right hand up so that it did not fall limp at his side? He who gazes at this becomes paralyzed. Who gave strength to Abraham's soul, so that his eyes did not grow dim, so that he saw neither Isaac nor the ram? He who gazes at this becomes blind."

Artists have improvised on the Scriptures by having either God or the angel stop Abraham as he is about to strike, and have emphasized a variety of elements from the impressive image of God checking Abraham's hand to Isaac's terror-stricken face, the knife at his throat.

Jacob Jordaens the Elder
1593–1678

The Sacrifice of Isaac

Brera
Milan
Italy

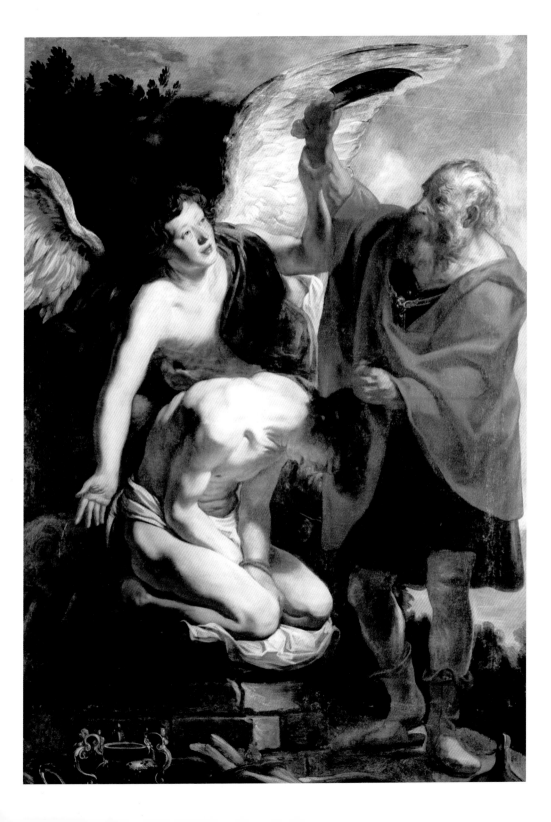

Rebecca's Well

When it was time to find a wife for Isaac, Abraham gave the mission to his chief steward, Eliezer, and set strict conditions on it. The future bride could not be an idolatrous Canaanite, and therefore the man was to go to Chaldea, Abraham's former homeland between the Tigris and the Euphrates, to seek a bride among Abraham's kin there. But she had to be willing to leave Chaldea, as Isaac had to live in the land God had given Abraham and his descendants.

In Chaldea, the servant made his camels lie down before a well outside the gates of the city of Nahor and with a prayer entrusted his complicated mission to divine wisdom. "Let the girl to whom I shall say, 'Please offer your jar that I may drink,' and she shall say, 'Drink, and I will water your camels'—let her be the one whom you have appointed for your servant Isaac."

Just then a girl named Rebecca came out of the city, filled her pitcher, and, at Eliezer's request, poured out water for him to drink, then tended to his camels. When asked, the girl told him that she was the granddaughter of Nahor, Abraham's brother. After thanking God for having guided his path, the servant gave Rebecca two golden bracelets and a nose-ring.

Rebecca's parents consented to the match and were quickly persuaded to let her leave for Canaan, where she married Isaac.

Nicolas Poussin
1594–1665

Eliezer and Rebecca

Louvre
Paris

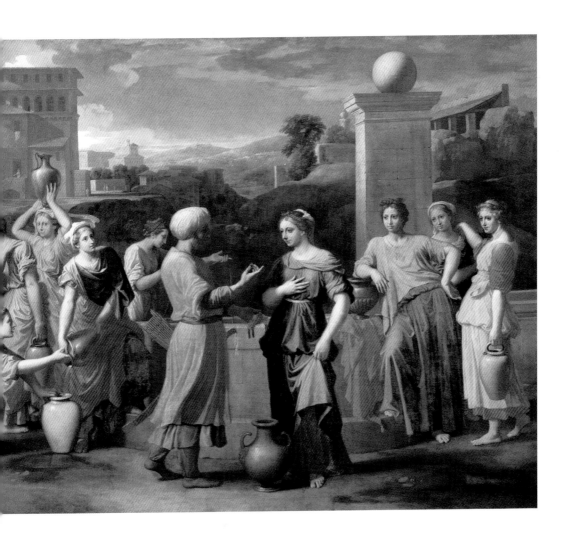

Isaac's Blessing

One day, when he was very old and almost blind, Isaac suddenly said to his eldest son, Esau the great hunter, "I do not know the day of my death," and sent him out to hunt, adding, "Then prepare for me savory food, such as I like, and bring it to me to eat, so that I may bless you before I die"—which blessing would make Esau his successor.

But Rebecca overheard this and preferring her second-born son, Jacob (partly because Esau had married pagan Hittite women), she saw in Isaac's blindness an opportunity for a deception that would establish Jacob in Esau's place.

Rebecca had Jacob kill and dress "two choice kids" from the herds and cooked them as the "savory food." Then she dressed Jacob in Esau's clothes so that he would smell like his brother and covered his face and his hands with the goat skins so that he would feel rough like him, and sent him to Isaac with the dish, to receive the blessing meant for Esau.

Isaac was deceived and blessed his younger son. Later, he could not withdraw his blessing despite the demands of Esau, furious at the trickery.

This benediction has given rise to many compositions, as many solemn paintings as ones touching on farce, with Rebecca at the door watching the outcome of her scheme.

Luca Giordano
1634–1705

Isaac Blessing Jacob

Harrach Family Collection
Rohrau
Austria

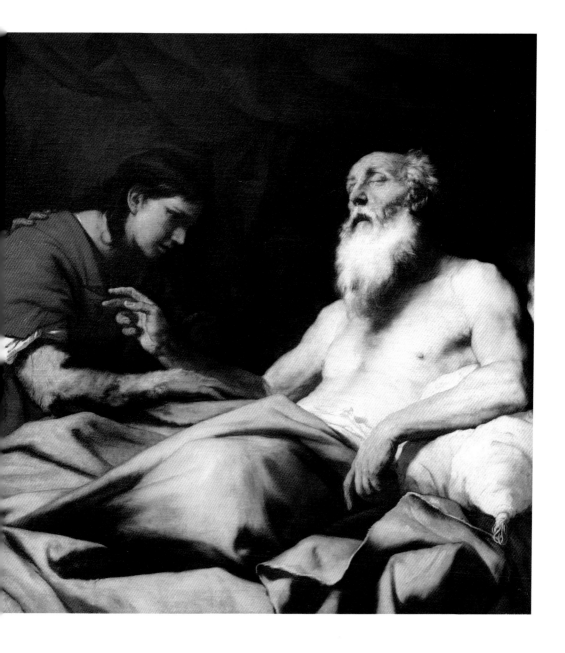

Jacob's Ladder

Journeying eastward to flee his brother's wrath, Jacob stopped for the night at a place called Bethel (where Abraham and Lot separated). He "took of the stones of that place for his pillows … lay down in that place to sleep," and dreamed of an immense ladder reaching from earth to heaven, with angels coursing endlessly up and down it, rising and descending.

Domenico Fetti
1588/89–1623

Jacob's Dream of the Ladder to Heaven

Kunsthistorisches Museum Vienna

Then God appeared to him and renewed the covenant he had made with Abraham: that this land would belong to him and to his innumerable descendants. Upon waking, Jacob realized that Bethel was a holy place. "For the Lord is in this place," he said, "this is the house of God and … the gate of heaven." He took the stone that had been his pillow, set it in the ground as a pillar and anointed it with oil. (This is strongly reminiscent of Mecca's Black Stone of Kaaba.)

Interpreted as a rite of passage leading the initiate from this world to the Ideal, with each rung marking a further step toward perfection, Jacob's Ladder is one of European painting's great allegorical themes. As a key esoteric theme it has also inspired Masonic painters.

A number of paintings also picture the anointed stone. To the British it clearly relates to the Scone Stone, a stone weighing 335 pounds that was captured by King Edward I of England in the thirteenth century from the Scottish kings and for a long time afterwards was embedded in the English throne in London. It resides today in Edinburgh Castle.

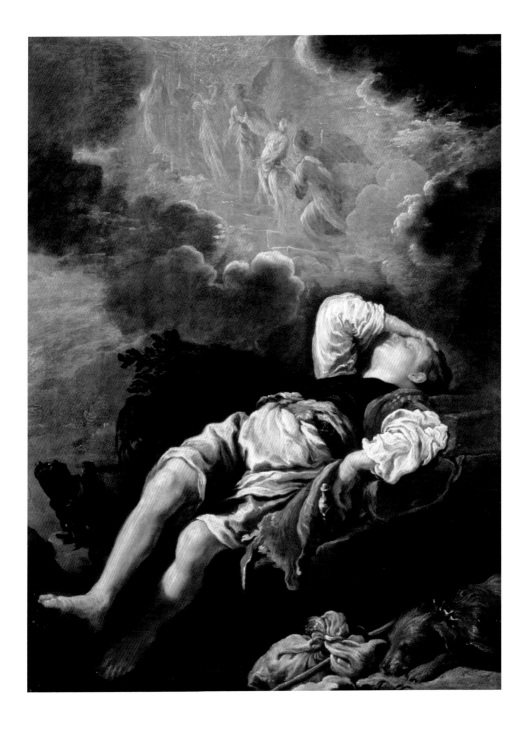

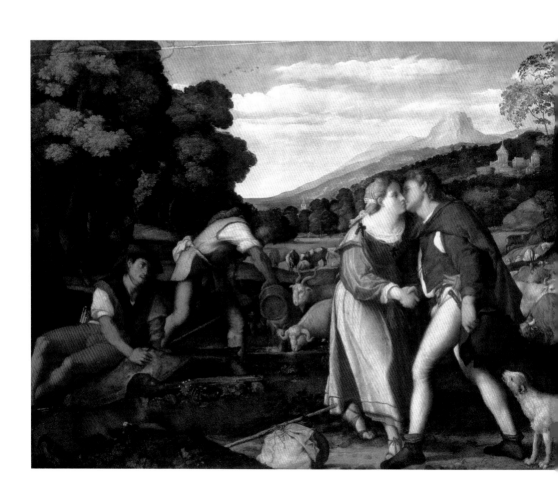

Jacob and Rachel

Jacob fled to Chaldea both to escape Esau's wrath and to find a wife among his mother's kin.

By a well in Chaldea he fell in love with Rachel, the daughter of his mother's brother Laban. In order to marry her he agreed to serve her father for seven years. But when the seven years has passed, Laban deceived him. Believing it proper for Leah, Rachel's elder and, as the Scriptures indicate, unlovely sister to be married first, after the wedding feast he put Leah into the bridal tent. Jacob discovered the trick only the next morning, Still in love with Rachel, he served Laban for an additional seven years in order to marry her.

Leah was the first to bear children, all sons. At the birth of the fourth, the still childless Rachel gave Jacob her servant Bilhah as a wife and adopted their sons as her own. Thus began what Rachel called "the mighty wrestlings" between the two sisters to give Jacob more children. When Leah herself failed to conceive she gave Jacob her servant Zilpah as wife, to compete with Rachel's Bilhah.

By his two wives and their handmaidens Jacob had twelve sons in all, in this order: Reuben, Simeon, Levi, and Asher (by Leah); Dan and Naphtali (by Bilhah); Gad and Asher (by Zilpah); Issachar and Zebulin (by Leah); Joseph and Benjamin (by Rachel). Leah also bore Jacob one daughter, Dinah.

The twelve sons of the son of Isaac became the ancestors of the twelve tribes of Israel.

Jacob and Rachel's meeting and their wedding have inspired a number of frescoes and paintings, scenes that are sometimes spiced by the presence of the ill-favored but fecund Leah.

Palma the Elder
(Jacopo Palma)
1479/80–1528

Jacob and Rachel

Gemäldegalerie, Alte Meister
Dresden
Germany

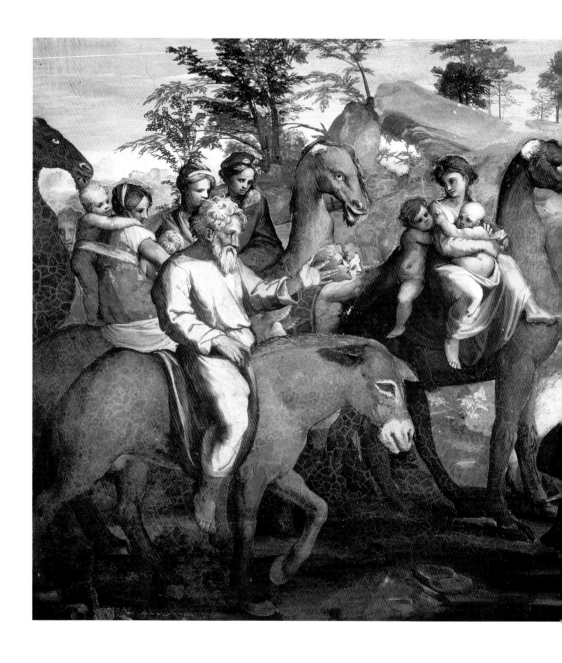

Jacob's Flight

Jacob served his uncle Laban, who was also his father-in-law, twice over, for a total of twenty years, building up his own flocks while he tended Laban's. His cousins, who were also his brothers-in-law, greatly resented his wealth, reckoning Jacob's gain as their loss. When tensions reached the kindling point, Jacob fled for Canaan with his wives, children, and livestock. Unbeknownst to Jacob, Rachel stole her father's household idols.

The furious Laban pursued his daughter and her husband his nephew and caught up with them at Mount Galaad, in Jordan. But as God had told him, "Take heed that you say not a word to Jacob, either good or bad," the confrontation proceeded courteously.

With Jacob's consent, Laban recovered the goods to which he had a right—except his idols. For as he was searching Jacob's tents Rachel hid them in her saddle and sat down on it, and when her father wanted to search it she told him she could not get up because "the way of women is upon me."

Then Jacob and Laban erected a sacred stone and sat down before it to apportion disputed territory. Jacob got the lands to the west of the stone and Laban retained those to its east, to which he and his party then returned. Jacob traveled on to Canaan and his father Isaac.

Paintings inspired by this episode are extremely diverse with respect to the moment depicted, as painters have been inspired by the themes of Jacob tending Laban's flocks; his flight; his journeys; Jacob and Laban; the forging of their treaty, and Rachel hiding the idols.

Raphael
(Raffaello Santi or Sanzio)
1483–1520

Jacob's Flight

Loggia of the Palazzi Pontifici
The Vatican
Rome

Jacob Wrestles with the Angel

One evening, when Jacob had already crossed the River Yabboq and was nearing the Promised Land, he had a strange encounter: a man wrestled with him until dawn. For a long time the struggle was indecisive, until the stranger touched a nerve in Jacob's hip, which immediately became numb.

"Let me go, for the day is breaking," the stranger said.

Sensing his divine nature, Jacob replied, "I will not let you go unless you bless me."

"You shall no longer be called Jacob, but Israel," the stranger said, "for you have striven with God and with humans, and have prevailed."

Still refusing to give his name, the celestial stranger nonetheless blessed his adversary, who then concluded, "I have seen God face to face, and yet my life is preserved." From then on Jacob limped, and this divine lameness is at the root of the Hebrews' prohibition against eating meat from the hips of animals.

Rembrandt
(Rembrandt van Rijn)
1606–1669

Jacob Wrestling with the Angel

Gemäldegalerie
Berlin

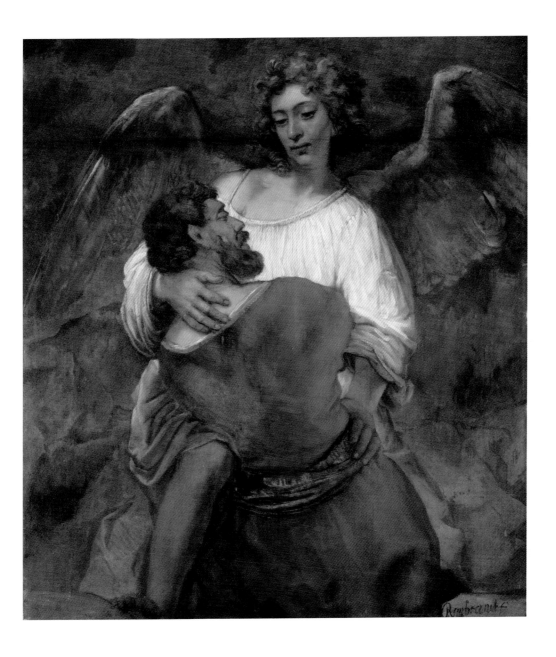

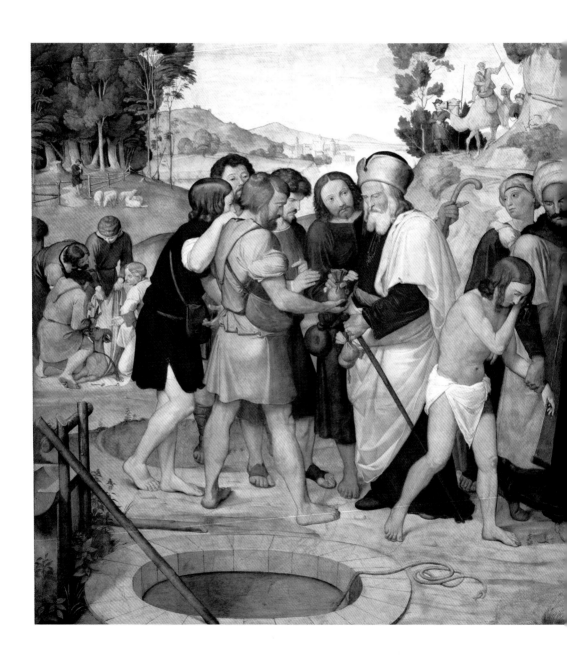

Joseph Sold by his Brothers

Joseph, Jacob's first son by his favorite wife, Rachel, was so much the object of Jacob's affection that his eleven brothers became jealous. When Isaac gave him a splendid multicolored cloak their jealousy reached new heights. Pasturing their flocks one day far from their father's tent, they saw Joseph coming across the fields to join them and decided to rid themselves of him, but not to kill him. When he came up to them they seized him, stripped him of his cloak, and threw him into an empty well, then sold him as a slave to a caravan of Ishmaelites on their way to Egypt. The price was twenty shekels—about 9¼ ounces of silver.

To pass off their crime as a catastrophe, the brothers cut a goat's throat, soaked the cloak of many colors in the blood and showed it to Jacob, saying Joseph had been devoured by a wild beast.

Jacob mourned for his favorite son, saying that he would weep as long as he lived.

In addition to the sale of Joseph to the passing Ishmaelite merchants, two scenes of this episode are frequently depicted: Joseph thrown into the well and Jacob viewing his son's bloody cloak.

Friedrich Overbeck
1789–1869

Jacob Sold by his Brothers

Nationalgalerie
Berlin

Potiphar's Wife

Sold as a slave by his brothers, Joseph was taken to Egypt by his new masters and sold to Potiphar, the chief of Pharaoh's guards. Thanks to his skills and intelligence, and the help of God, who "caused all that he did" for Potiphar "to prosper in his hands," he soon made himself indispensable to his master and was appointed overseer and manager of the entire household.

But when Potiphar's wife "cast her eyes on Joseph" she came to think him indispensable to her and tried relentlessly to entice him into her bed. The young Hebrew, however, loyal to his master and fearing God, resisted her so steadfastly and coldly that one day she violently pulled him into her bed. Joseph freed himself and ran from her bedroom, leaving his cloak in her hands.

Potiphar's wife accused Joseph of having wanted to seduce her, and brandished the cloak as proof. When Potiphar heard her story he flew into a rage and threw Joseph into the royal prison.

Such a scene of seduction could not fail to inspire artists. But in the manner of Late Medieval and Early Renaissance painters, the anonymous master of the painting here has extended the work's key moment into the story's future by including small background images of Potiphar's wife before her husband and of Joseph being taken to prison. Thus in the viewer's imagination the scene of seduction becomes just one of the stages of Joseph's progress to his eventual greatness.

The story of a high-born woman trying to conceal her shame by telling her husband that a younger man had tried to seduce her has many versions in antiquity, which have inspired many writers. As the Greek myth of Phaedra's accusation of her stepson Hippolytus to his father, king Theseus of Athens, which results in Hippolytus' death and Phaedra's suicide, it became Euripides' tragedy *Hippolytus,* which in turn inspired the French playwright Jean Racine's *Phèdre* (1677).

Master of the Joseph Legend
c. 1490–1500

Joseph and Potiphar's Wife

Alte Pinakothek
Munich
Germany

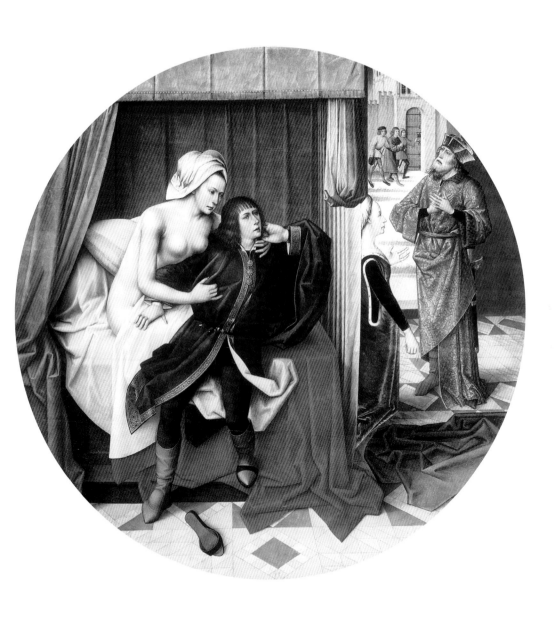

Joseph in Prison

Joseph made himself as indispensable in prison as he had been in Potiphar's palace. Soon it was he rather than the warden who was in charge. But his subsequent release and rise to power were due to his gift of interpreting dreams.

In the prison were two of Pharaoh's former high administrators, who had been having troubling dreams and came to Joseph with them. After listening to them, Joseph assured the chief cupbearer that Pharaoh would eventually pardon him and restore him to his post, and predicted a hanging for the chief baker.

Anton Raphael Mengs set his painting's scene at the moment when Joseph has just finished interpreting both dreams. The chief cupbearer, whose dream came first, is still gazing thankfully toward heaven while the chief baker recoils in terror from the prediction of death that he has just heard.

These predictions came true, but when the chief cupbearer was back in office he forgot Joseph, who languished in prison for two more years before his skill with dreams changed his fate.

Anton Raphael Mengs
1728–1779

Joseph in Prison

Albertina Museum
Vienna

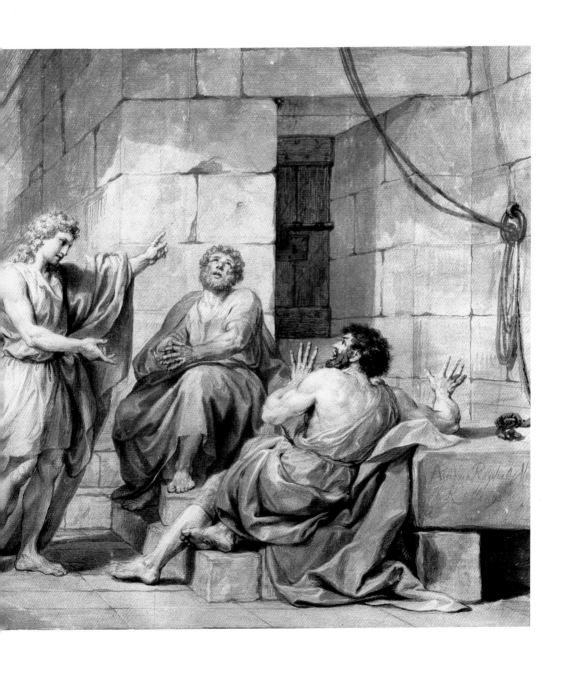

Joseph and Pharaoh

After dreaming two troubling, enigmatic dreams, Pharaoh sought their meanings. The chief cupbearer remembered "a young Hebrew" who had correctly interpreted a prophetic dream for him in prison, and had Joseph sent for.

Pharaoh dreamed of seven fat cows coming out of the Nile, followed by seven lean ones who devour them, and of seven heads of wheat growing on a single stalk smothered by seven wind-scorched heads growing on another.

The meaning, Joseph said, is that Egypt could expect seven abundant years followed by seven years of famine.

He then proposed that Egypt prepare herself by setting aside a fifth of each year's abundant harvest as a reserve to supplement the seven ensuing poor ones. Amazed by such great wisdom, Pharaoh entrusted the project to Joseph, who saw himself instantly elevated by the appointment from prisoner to viceroy.

When the long famine came, Joseph sold the Egyptians' grain back to them, first for money, then for their flocks, then for their fields, and finally—the Egyptians choosing slavery over starvation—for their bodies.

This explains Pharaonic Egypt's social organization into almost universal serfdom. Only the priests remained free, retaining the use of temple property and lands.

In their depictions of the dreams themselves, of Joseph interpreting them, and of Joseph as economic planner, painters have freely invented and elaborated on the costumes, architecture, and décor of their paintings' ancient Egyptian settings.

Adrien Guignet
1816–1854

*Joseph Interpreting
Pharaoh's Dreams*

Nationalgalerie
Berlin

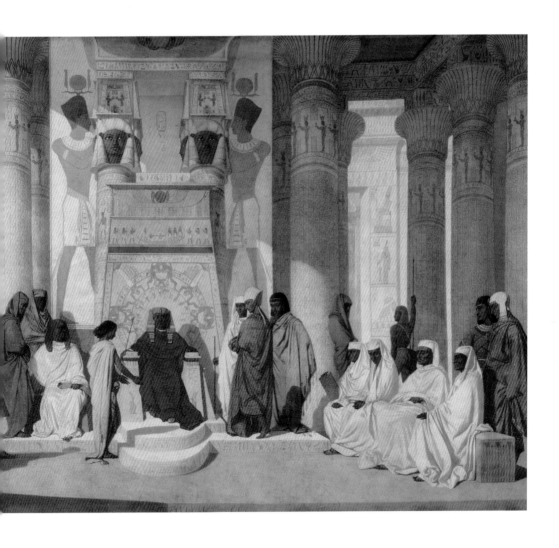

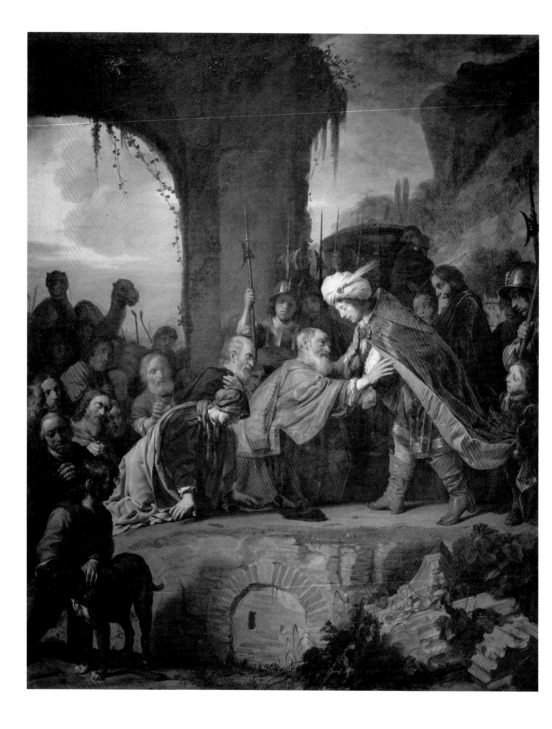

The Reunion of Joseph and his Brothers

Salomon de Bray

1597–1664

Joseph Welcoming his Father and his Brothers in Egypt

Private Collection

With famine raging in Canaan as well as Egypt, ten of Joseph's eleven brothers went down to Pharaoh to buy provisions. Only the youngest, Benjamin, the child of Jacob's old age by Joseph's mother, Rachel, stayed with Jacob.

Joseph recognized his brothers but, thoughts of revenge overwhelming his heart, concealed his identity from them. But it never entered the minds of Reuben, Simeon, Asher, Dan, and the others to wonder if he were Joseph, so different was the Egyptian viceroy before their eyes from the memory of the boy they had, in far-off Canaan so long before, stripped half naked, thrown into an empty well, and sold as a slave to traveling Ishmaelite merchants.

At first, Joseph accused them of being spies. Then, keeping two as hostage, he sent them back to Canaan with orders to return with Benjamin. The aged Jacob held out long against this demand but, hard pressed by famine, had to let Benjamin go.

Joseph did everything to keep Benjamin from going back to Canaan, even to the point of hiding a precious goblet in his luggage and then accusing him of theft. But in the end the sight of his beloved brother melted his heart and he told his brothers who he was. All thoughts of revenge having fled his mind, he urged them to settle in Egypt with their families and flocks, bringing their father, to whom God had said, "Joseph's own hands shall close your eyes."

On their return and after his tearful reunion with Jacob, Joseph ceremoniously presented four of his brothers to Pharaoh, who gave the Hebrews the land of Goshen, in the eastern part of the Nile delta.

Pictorial tradition sometimes shows the goblet being discovered in Benjamin's baggage, most often as a golden cup belonging to Pharaoh. However, the moving scene of the father and son's reunion is the moment most often depicted.

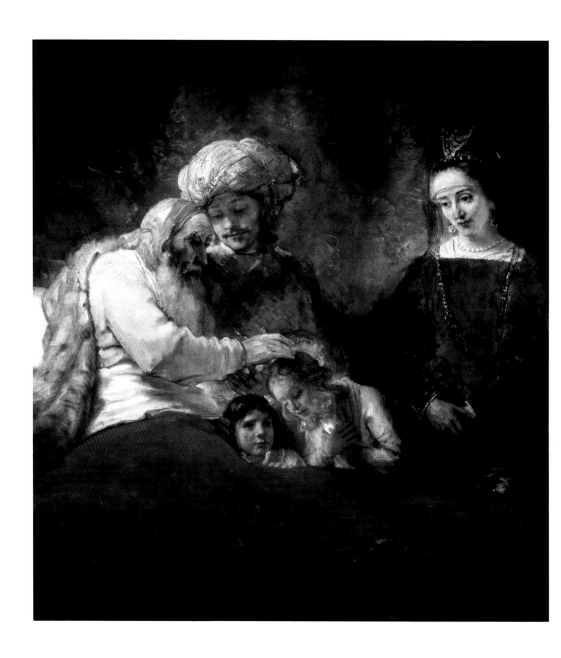

Jacob's Blessing

Rembrandt
(Rembrandt van Rijn)
1606–1669

*Jacob Blessing the Children
of Joseph*

Staatliche Museen Kassel
Kassel
Germany

Settled in Egypt and sensing the approach of death, Jacob carried out two successive solemn benedictions. First, he recognized as his, and as equal to his own offspring, Ephraim and Manasseh, born to his son Joseph by the daughter of Potiphera, priest of the Egyptian god On. And indeed there are paintings of "The Wedding of Joseph and Potiphar's Daughter."

Manasseh was the elder, but Jacob placed his hand on Ephraim's head, thus giving precedence to the younger. This act is later translated into geographical terms by the difference in the lands given to the two tribes descended from Joseph's two sons.

The second benediction was of Jacob's own children, and is the strange and solemn institution of the twelve tribes of Israel and their particularities. He effectively disinherits Reuben, the eldest, who "went up into your father's bed; then you defiled it"—his tribe is to live east of the Jordan; for Simeon and Levi he promises no lands of their own, because of their violence; Issachar he calls "a rough donkey" who preferred rest to labor and so condemns him to slavery … . These are predictions more than blessings, a suite of oracular pronouncements of the tribes' destinies after their return to Israel. However, pictorial tradition features the benediction's quasi-sacramental aspect.

With characteristic humanity, Rembrandt has deeply imagined each figure in the scene with respect to his or her age, sex, and role in the story. He has thus expressed both the episode's sacramental content and the moment's effect on his characters' feelings. He gives particular emphasis to the feelings of Jacob as he blesses Joseph's sons, and to those of the boys themselves, too young to appreciate the gravity of the situation; their faces glow with childhood's delight at things experienced for the first time. By depicting Joseph and his wife but not Joseph's eleven brothers, some of whose blessings were inauspicious, Rembrandt concentrates his attention on the event's softer emotions.

The Finding of Moses

Many years after the death of Joseph and his brothers, "A Pharaoh who did not know Joseph" came to the throne. Seeing "how numerous and … powerful" the Israelites had become, he enslaved them and ordered all future sons to be killed at birth.

Hoping to spare her first-born from this sentence, a young woman from the tribe of Levi coated a reed basket with bitumen and pitch, placed the baby, the future Moses, in it, and put it among bulrushes in the shallows of the River Nile, where Pharaoh's daughter and her handmaidens always went down to bathe.

When Pharaoh's daughter found the basket she understood the situation at a glance and was moved with pity. Moses's elder sister, who, at her mother's bidding, was watching from the reeds, came out of hiding, offered to find a nurse for the child, and came back with its mother. And so the child received a princely upbringing from its adoptive mother, who named him Moses, and a Jewish one from his nurse, his true mother.

The discovery of the basket is one of the most popular Old Testament themes in the European tradition of iconographic religious painting. Nicolò dell'Abate's painting illustrates the freedom painters enjoyed with respect to the details of Old Testament scenes. Although nominally set in Egypt, the discovery of the basket occurs in a stylized European landscape. In the background is an imaginary European city, yet its curiously designed buildings and towers refer more to the Orient than to Abate's native Italy. Pharaoh's daughter and her handmaidens are dressed in Western painting's conventional versions of Ancient Greek and Roman robes.

Nicolò dell'Abate
c. 1509–1571

The Finding of Moses

Louvre
Paris

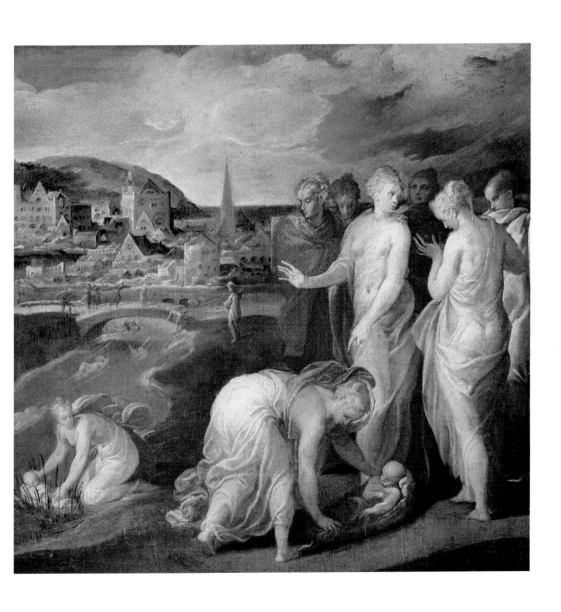

Moses and Jethro

As an adult, Moses looked Egyptian and lived among the nobility but he knew himself to be a Jew and identified with his people, so much so that when he saw an Egyptian beating a Hebrew slave one day he killed him. Thinking that no one saw him, he buried the corpse in the sand. But a few days later, a Hebrew he was berating for some act or other, barked at him, "Who made you a ruler and a judge over us? Do you mean to kill me as you killed the Egyptian?"

Realizing that everyone would soon know about his crime, he decided to flee Egypt. In fact, Pharaoh already wanted to put him to death for his act.

As a refugee in the land of Madian, northeast of the Gulf of Aqaba, Moses had a new occasion for exercising his talents as judge. The seven daughters of Jethro, a priest of the region, brought their little flock to drink at a well and were chased away by shepherds who thought that their own flocks had the right to drink first. Moses took up the girls' defense, drew the water himself, and helped the young women give it to their sheep.

The grateful father invited the stranger to live with him, and gave him his daughter Sephora as wife.

The Scriptures also call this Madianite priest Raguel, or Hobab, but Christian tradition has kept the name Jethro.

Moses's forced wanderings in the desert, his meeting with the young women, and the father's invitation have given birth to many dramatic or pastoral paintings depicting the handsome young man, the noble father, and beribboned shepherdesses.

Rosso Fiorentino
(Giovanni Battista di Jacopo Rosso)
1494–1540

Moses Defending the Daughters of Jethro

Uffizi
Florence
Italy

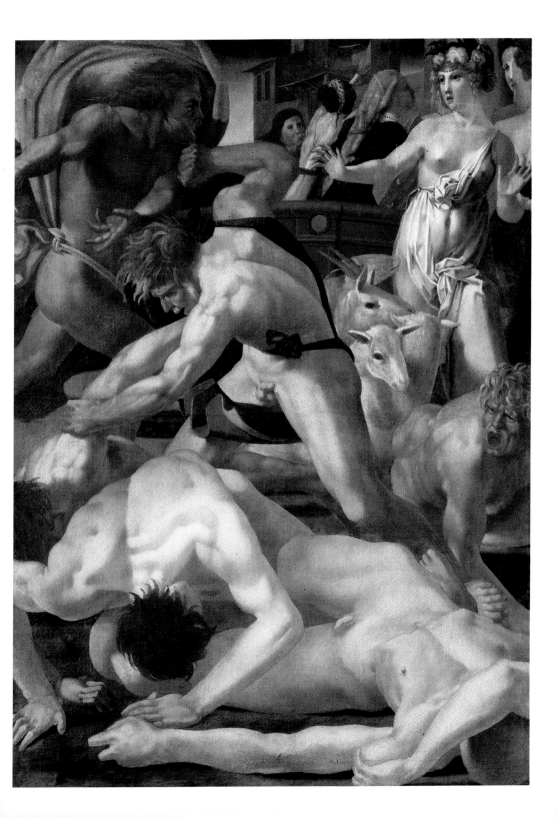

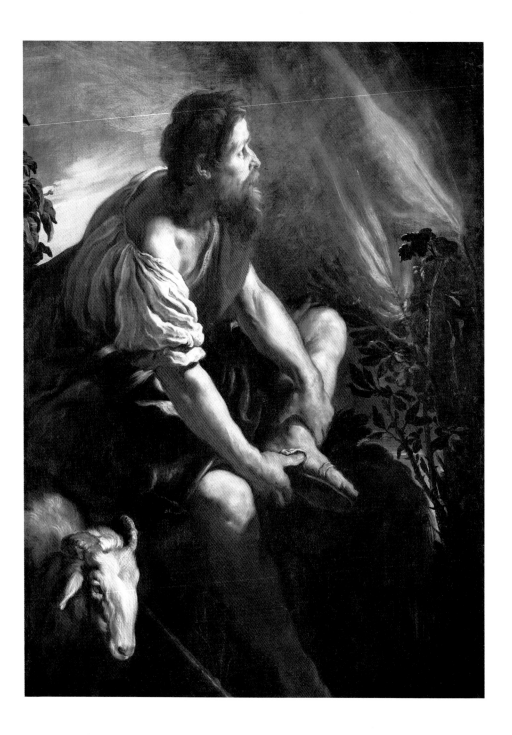

The Burning Bush

Domenico Fetti
1588/89–1623

*Moses before the
Burning Bush*

Kunsthistorisches Museum
Vienna

Moses was tending his father-in-law Jethro's flock on the slopes of Mount Horeb near Sinai one day when suddenly he saw flames rising from a bush, which, however, the fire did not consume. As he approached it, God told him to take off his sandals before setting foot on this sacred spot. Then God spoke of the Hebrews' suffering and concluded with, "I will send you to Pharaoh to bring my people, the Israelites, out of Egypt."

Moses was overwhelmed by self-doubt, asking God why he should be chosen for such a task. "I shall be with you," God replied, and told him of a sign by which it would be known that the mission came from him. And what name, Moses asked, should be used to tell the Israelites who sent him? "I am who I am," God replied.

When Moses doubted the Israelites would even listen to him, God told him to throw his staff to the ground. When it landed it turned into a snake.

Moses shrank back in fear. God told him to pick up the snake and when he did it turned back into the staff. This, God said, would be a sign "that the Lord … has appeared to you."

"But I am slow of speech and slow of tongue."

"I will be with your mouth."

"O my Lord, please send someone else."

"What of your brother Aaron? He shall serve as a mouth for you."

Moses had nothing more to say. He left Mount Horeb, took leave of Jethro, and went to Egypt with Aaron.

The depiction of God appearing in the forms of fire, light, or a whirlwind presents painters with the challenge of making a non-human phenomenon into a main character of a human story. Domenico Fetti has met the challenge by relegating the stylized burning bush to the status of a background detail and concentrating on the entirely human moment of Moses removing his sandals.

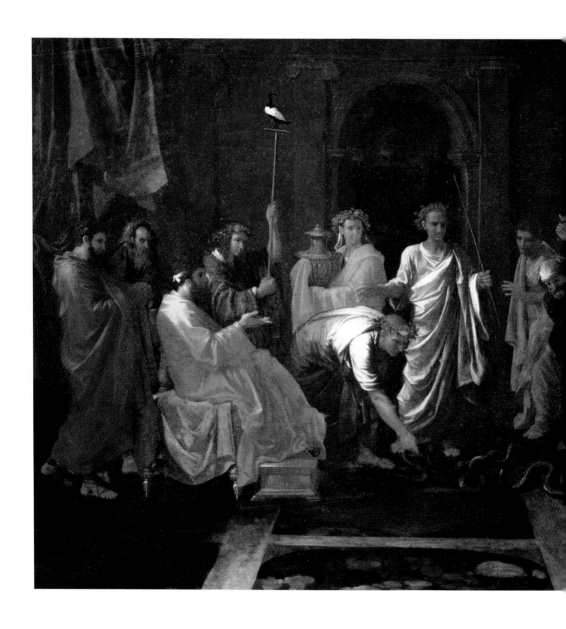

Moses before Pharaoh

Before Pharaoh, Moses did not ask for the liberation of his people but rather for a three-day holiday so that they might sacrifice to their God in the near desert. As proof of the divine nature of their mission, Moses had Aaron change his staff into a serpent. Pharaoh's magicians immediately did the same thing with their staffs. Aaron's serpents then devoured the magicians'.

Still, Pharaoh was not convinced. On the contrary, he grew more oppressive, ordering that the brick makers among the Hebrew slaves henceforth provide the necessary straw themselves.

With their people's situation worsening, Hebrew leaders who had believed in Moses turned against him.

Moses appealed to God, who explained that He himself had hardened Pharaoh in order to justify the great punishments that He reckoned necessary to bring him to his knees, and which were about to be visited upon the land.

With respect to this story it must be said that painters have devoted less attention to the Hebrews' misery than to the magic contest between the Egyptian priests, Moses, and Aaron.

Nicolas Poussin
1594–1665

Moses Changing Aaron's Staff into a Serpent

Louvre
Paris

The Feast of Passover

Men in traveling clothes, cords around their waists, sandals on their feet, staffs in hand, eating standing up—the bread hasn't had time to rise, the meat is broiled instead of slowly boiled; for garnish, bitter wild herbs plucked nearby … . These are the Jews celebrating the first Passover while preparing their sudden flight. They have smeared their doorposts and lintels with the blood of the broiled lambs, for this same night God's exterminating angel, the last of the ten plagues, will course through Egypt.

Wails of anguish resound from houses everywhere as throughout the land the first-born die. Only those homes marked by paschal blood are spared.

Following Moses's instructions, the Jews, men and women alike, have borrowed as many garments and gold and silver objects as they could from their Egyptian neighbors. And when terror-stricken Pharaoh at last consents to their departure everyone is ready, carrying kneading troughs and unleavened dough on their shoulders.

The founding event of a great Jewish festival is at once a moment of anguish and a hope for deliverance. Christian artists have treated this "feast of the lamb" as a prefiguration of the Last Supper and Easter.

Dieric Bouts
c. 1415–1475

The Feast of Passover
(left wing of Last
Supper Altar)

Église St. Pierre
Leuven/Louvain
Belgium

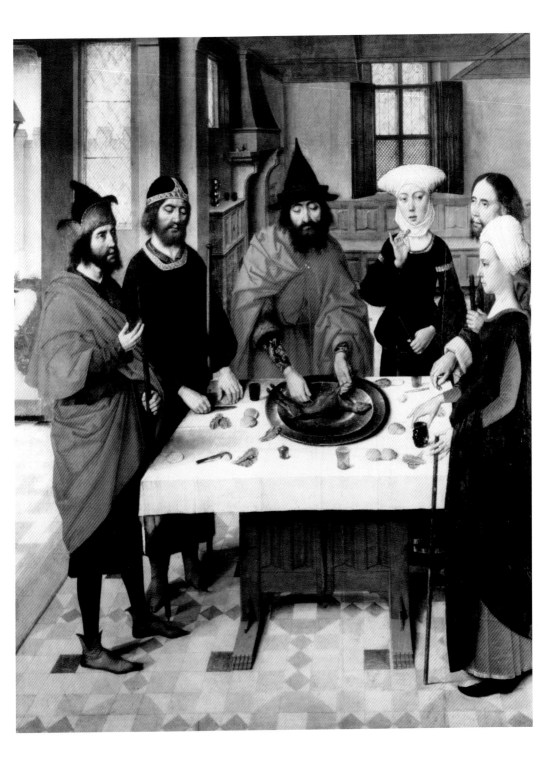

The Ten Plagues of Egypt

Responding to Pharaoh's stubbornness, God crushed Egypt with ten successive plagues.

PAGES 94–95

Sir Lawrence Alma-Tadema
1836–1912

The Death of the First Born

Rijksmuseum
Amsterdam

WATER INTO BLOOD

Aaron struck the river with his rod and the waters became red and undrinkable. But the Egyptian magicians showed that they could do the same, and the fellahin dug wells to provide potable water.

FROGS

With a second blow of Aaron's rod, croaking frogs swarmed over the land. Again, the Egyptian magicians did as much, so Pharaoh wasn't impressed. At Pharaoh's command, Moses made the frogs die "and a great stench rose up in the houses and courtyards and fields of Egypt."

GNATS

Aaron struck the dust of the earth and the country was covered with gnats. When the magicians failed to do the same they warned Pharaoh that the situation was becoming grave. But he refused to take it seriously.

FLIES

God raised up clouds of flies that covered the whole land except for areas where the Jews lived apart. Pharaoh agreed to let Moses and his people perform their sacrifices to their God, but only in Egypt, then relented and said they could go to the edges of the desert but as soon as the flies were gone he broke his word.

PLAGUE ON THE LIVESTOCK

All the Egyptians' livestock died of sickness, but in the Israelites' flocks, not one animal fell sick. Pharaoh held firm.

BOILS

Men and beasts were covered with ulcerous sores. The magicians did not dare to show themselves in public, being themselves covered with boils. Pharaoh remained stubborn.

HAIL

An unprecedented storm rumbled over all of Egypt except for the Land of Goshen, where the Hebrews lived. Hail tore the crops and vegetation to shreds. Pharaoh promised to let the Jews go, but as soon as the hail stopped he broke his word.

LOCUSTS

Moses made his demands more precise. It was no longer just a matter of going to pray in the desert but of a true exodus of all the people, young and old, with all livestock. When Pharaoh refused, clouds of locusts darkened the sky and devoured everything the hail had left. Again, Pharaoh agreed but when the locusts left Egypt he again forswore himself.

DARKNESS

Egypt was plunged into darkness for three days. Pharaoh finally accepted the exodus of the Jews, but on condition that they leave their livestock behind. Moses refused.

THE DEATH OF THE FIRST-BORN SONS

The prophet proclaimed the death of every first-born son from Pharaoh's palace down to the hut of the poorest slave. And that night he instituted the first Passover and bound the Jews to the observance of its rites ever after.

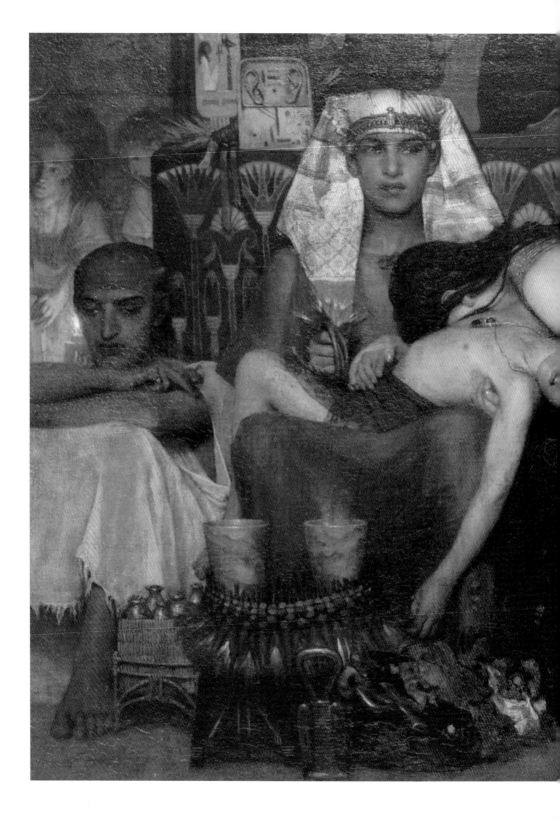

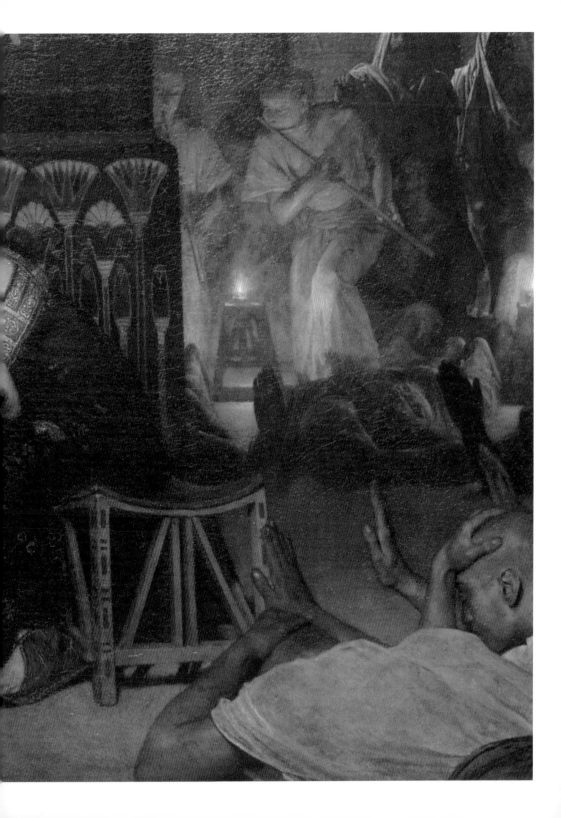

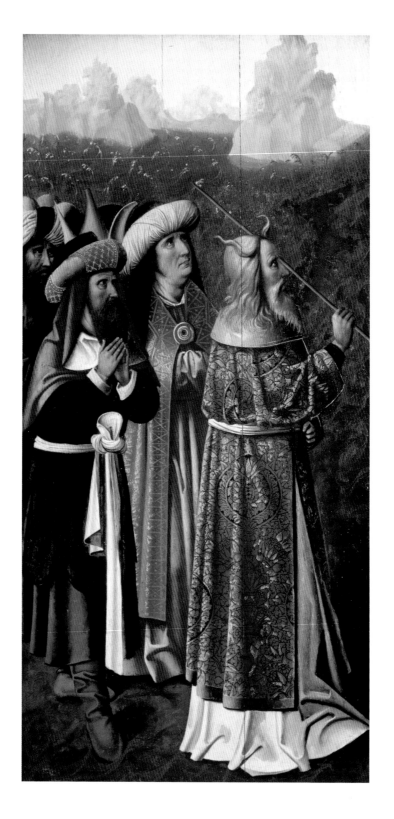

The Crossing of the Red Sea

Colijn de Coter
(attributed to)

fl. c. 1480–1525

Moses Parts the Red Sea

Musée Rollin
Autun
France

The Hebrews set out, guided by a pillar of cloud by day and a pillar of fire by night. Instead of telling them to take the shortest route, along the Mediterranean coast, God told them to veer toward the southeast, toward the Red Sea. While they were camped by its banks, in Egypt Pharaoh and his people, recovered from their terror, leapt to the pursuit, with six hundred chariots, horses, and knights—the whole Egyptian army.

Then Moses pointed his rod at the waves and the Red Sea parted in two, creating a sunken dry path between the two watery walls.

God took care to delay the Egyptians so that the Hebrews were already on the opposite shore when Pharaoh's army entered the dry path. Moses stretched his arm out again, pointing at the sea, and the waves flowed back into one another, drowning the whole Egyptian expedition.

As in the case of the plagues of Egypt, some commentators have tried to rationalize the miracle by asking which natural phenomena might be discerned behind these legendary accounts. Nevertheless, the Crossing of the Red Sea is one of the best-known episodes in the Old Testament.

Colijn de Coter has surmounted the difficulty of painting motionless waves by filling much of the canvas with the large foreground figures of Moses and his followers, and directing the viewer's gaze to the splendor of their highly detailed ornate costumes. Thus the red waves are just vivid and realistic enough to allude to the Red Sea but small and stylized enough to be mostly decorative.

Manna

Six weeks after the Hebrews entered the Sinai peninsula their provisions started to run out and the people began to grumble, nostalgic for the bread and meat they left behind in Egypt.

Before this, to slake their thirst, Moses had had to have recourse to a miracle, throwing wood into bitter water to render it drinkable. Now God intervened a second time so that his prophet could predict to his people. "At the twilight you shall eat meat, and in the morning you shall have your fill of bread." At nightfall, great waves of migratory quail fell to earth in the desert. In the morning, the ground was covered with a kind of granulous powder, like semolina, and Moses told his people to gather as much as they needed for that day and night.

Some of his people gathered more but the excess spoiled overnight. Only a double harvest on the sixth day of the week remained fresh throughout the seventh, the Sabbath, during which even the gathering of food is prohibited. As God himself rested as well, there would be no manna on Sabbath day.

Christians relate this miracle of manna from heaven to two of their own traditions: Jesus's multiplication of loaves by the Sea of Galilee, and the Eucharist. These reinterpretations have strongly influenced artists' depictions of this Old Testament scene.

Also influencing Leandro Bassano's painting shown here is a kind of sixteenth- and seventeenth-century print showing the several stages of a complicated activity like reaping or building all in one image. He has employed this pictorial convention to express not only the gathering, sharing, eating, and storing of manna all in a single moment, but also the Israelite's solemn response to the miracle. Moreover, he has given Moses a central but not a dominating role in the composition. In this painting, then, the importance of the event lies not in Moses's power to work miracles but in his ability to provide for the people he has led into the desert and who share the painting's moment with him.

Leandro Bassano
1557–1622

*The Gathering of
the Manna*

Santissimo Redentore
Venice
Italy

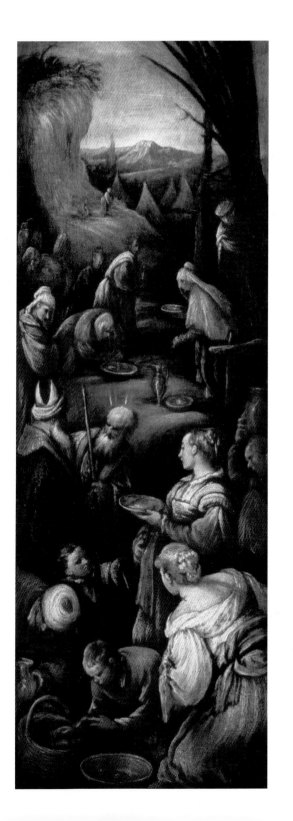

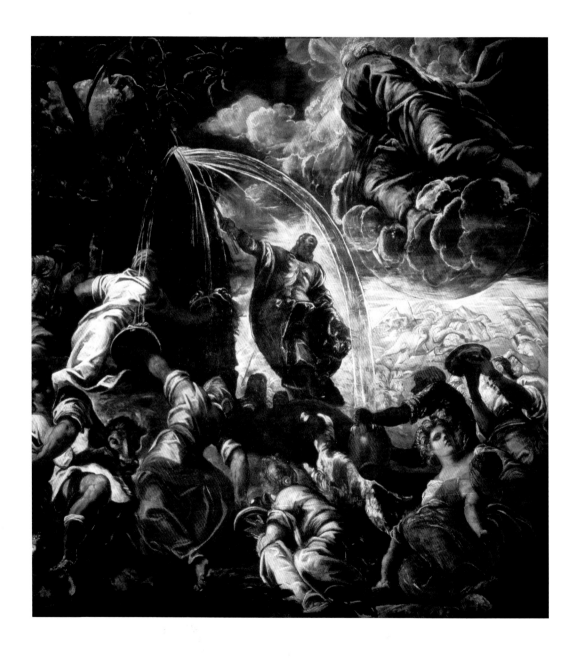

Water from the Rock

Tintoretto
(Jacopo Tintoretto)
1519–1594

Moses Striking the Rock

Scuola Grande di San Rocco
Venice
Italy

As they wandered on through the Sinai desert, the Hebrews ran out of water. Once more they yearned for Egypt and once more they confronted Moses, who, true to his nature, complained to God, saying, "They are almost ready to stone me."

And once more God came to Moses's aid by having him perform a miracle. "Take in your hand the staff with which you struck the Nile and go … . Strike the rock, and water will come out of it, so that the people may drink."

Tintoretto is one painter who met the challenge of depicting the non-human elements of miracles with a bold use of intense visual effects, such as the arching streams of water and the semi-transparent clouds in the work seen here. But he always balanced these spectacular aspects of his paintings with realistic handling of his gesturing figures and their compellingly emotional faces. Also contributing to the painting's strangeness but preventing the viewer from dwelling on the foreground effects is the mysterious small background scene of the pale horse and rider dashing through a pale landscape.

This spring of living water became an important Christian symbol, representing the Grace of God. St. Paul likens Christ to the rock itself.

Much later, and much closer to the Promised Land, Moses again made water spring from a rock, but sinned while doing so. For he struck the rock twice, thus betraying his lack of faith. To punish him, God refused to let him enter Canaan, and he died just before the Jews crossed over into it.

This second, sinful episode is sometimes confused with the first, innocent one, but it is the first that painting usually depicts.

The Sinai of today is sprinkled with so-called "rocks of Moses" from which, however, not a trickle of water has ever flowed.

The Ten Commandments

God summoned Moses to the top of Mount Sinai, there to receive from God's own hands the basic laws of the recently liberated people— the Ten Commandments, together with many other laws and instructions concerning religious and civil organization, including social and religious laws, the institution of slavery, the justice system, the establishment and terms of annual festivals, the plan of the temple, specifications for the construction of the Ark of the Covenant, its framework, curtain, altar, and lamps, and for the rites and sacrifices and the vestments, ordination, and organization of the priesthood. The Tablets of the Law (most likely clay but perhaps stone), written by God himself and given to Moses, were to be placed in the Ark.

While Moses was receiving the Law on Mount Sinai, the Israelites in the desert below began the worship of the Golden Calf. To place the two events side by side so as to be faithful to the Scriptures' sense of *time* Lucas Cranach the Elder has disregarded the reality of *space*. In his painting here, the top of Sinai is level with the floor of the porch where the Israelites' idolatrous worship begins. Yet he has departed from the Scriptures by turning the idol of the Golden Calf into a golden statue of a slender young Roman god.

Lucas Cranach the Elder
1472–1553

The First Commandment

Lutherhalle
Wittenberg
Germany

The Worship of the Golden Calf

When Moses was with God on Sinai, the Hebrews, still yearning for the lost comfort of Egypt, asked Aaron for a god "who shall go before us."

With women's and children's gold rings, Aaron fashioned a golden calf. Aaron seems to have wanted to hedge his bets, for once the idol was finished he tried to link it to the belief in the one God by crying, "Tomorrow shall be a festival to the Lord!" But he also supported their paganism by making them "naked unto their shame."

When Moses came down from Sinai and saw the ritual he broke the tablets of the law and summoned Aaron, who claimed that he had tried to prevent the idolatry by confiscating the people's gold and throwing it into the fire but "there came out this calf."

Seeing the people's nakedness, Moses shouted, "Who is on the Lord's side? Come to me!" When his own tribe of Levi gathered around him, he ordered a symbolic but nonetheless horrific punishment of the idolaters. "Go back and forth from gate to gate throughout the camp, and each of you kill your brother, your friend, and your neighbor." Three thousand people died.

Moses then returned to the top of Sinai, where he stayed for forty days talking with God, who again set forth the laws, which, this time, Moses transcribed himself.

The image popularized by many Western paintings is of Moses coming to his people from this second meeting, haloed in light and carrying stone tablets of the law. Most often, he has a pair of horns at his temples, for the Bible states that after the second meeting atop Sinai rays of light shot from his forehead and he veiled them with a cloth that he removed only in the presence of God. The Latin translation of the Old Testament, attributed to St. Jerome, speaks of "horns" rather than rays, and all painters and sculptors have taken up this tradition.

Andrea Celesti
1637–?1712

The Punishment of the People of Israel for Worshipping the Golden Calf

Doge's Palace
Venice
Italy

The Brazen Serpent

The episode of the Golden Calf notwithstanding, Exodus acknowledges a legitimate religious function of painted or sculpted representations of living beings.

As God did not want the generation who had left Egypt with Moses to enter the Promised Land, he made the wandering in the desert last for years. After the deaths of this generation, including that of the high priest Aaron, the people of Israel found themselves once again by the Red Sea. Once more they were weary of eating manna, and the mixed crowd of non-Israelites who had been with them from the start began to complain endlessly, regretting "the fish we used to eat in Egypt for nothing, the cucumbers, the melons, the leeks, the onions, and the garlic."

God punished them by sending poisonous snakes against them. Many people fell victim to them. Once more Moses interceded and God told him the remedy. "Make a poisonous serpent and set it on a pole; and everyone who is bitten shall look on it and live."

And so the prophet fashioned a bronze serpent, which performed the function of antidote to perfection.

It is an ambiguous episode, in which a monotheistic people seems to supplicate an idol, but the intercessionary role falling to the serpent, to the extent that it justifies the numerous intermediaries between man and the divinity that Christianity recognizes, became a popular theme of iconographic painting.

Tintoretto
(Jacopo Tintoretto)
1519–1594

The Brazen Serpent

Scuola Grande di San Rocco
Venice
Italy

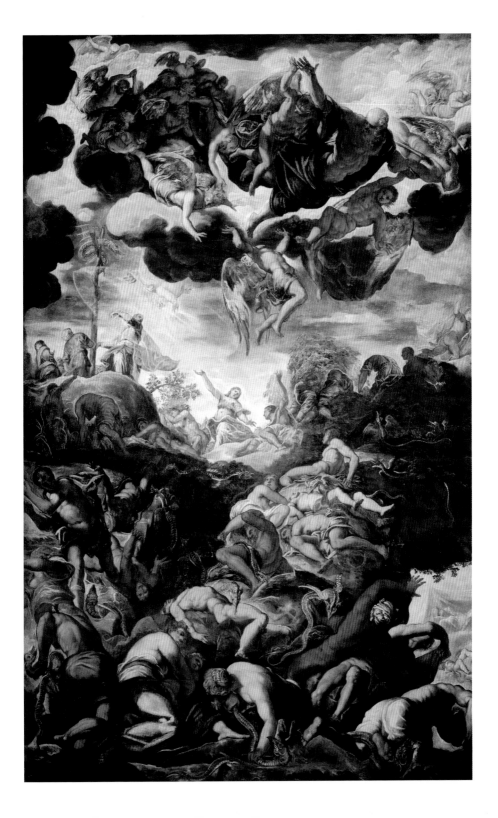

The Spies in Canaan

On at least two occasions, Moses sent spies into the land that was to become Israel. The first expedition was the more important. It included a representative of each of the twelve tribes and lasted forty days. The explorers returned with figs, pomegranates, and a bunch of grapes so large that two people had to carry it on a beam. They reported that Canaan was indeed a land "of milk and honey."

Nonetheless, they tempered their report with a somber warning: the cities were fortified, the people numerous and powerful; the land might be promised but it certainly wasn't given.

As before when facing hardship, the "stiff-necked people" grumbled and spoke of going back to Egypt. Only two of the twelve spies supported Moses by saying that the land could be conquered. Caleb spoke first, followed by Joshua, who later led the campaign.

This further delayed the entry into the Promised Land, for none of those who objected was deemed worthy of conquering it. Of the spies, God favored only Caleb and Joshua with crossing the Jordan.

For painters, the important theme of this episode was always the Land of Cockaigne on Jordan's far banks, a land where the fruit surpasses the promise of the blossom. The spies' return is often treated in ways also found in bucolic paintings of secular agricultural fairs and harvest festivals.

Nicolas Poussin
1594–1665

Autumn, or *The Messengers from Canaan*

Louvre
Paris

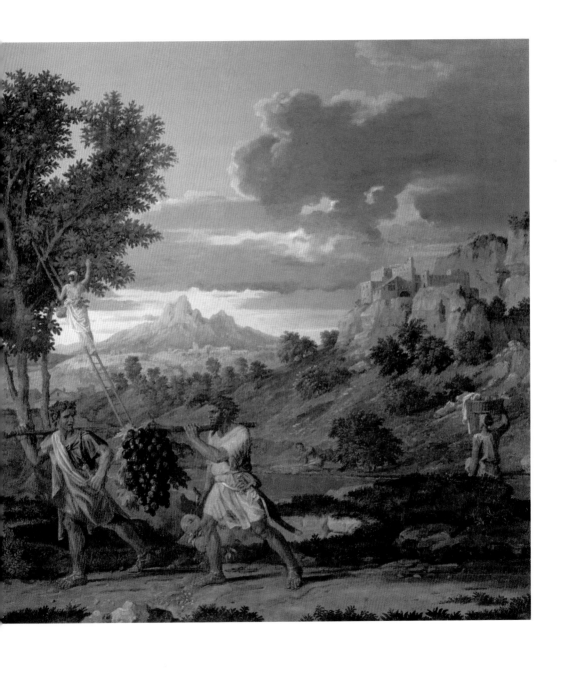

Balaam

Even before entering Israel, the Hebrews had to survive some hard fighting. Instead of entering the Promised Land by the most direct route, from Sinai in the north, Moses took a roundabout route from east of the River Jordan, through today's Jordan, where they met stiff opposition from the Moabites and Midianites, whose territory fell to the tribes of Gad and Reuben. This occupation, albeit provisional, was not to the taste of local populations, but the Israelite army was strong.

The Moabite king Balak sought help from Balaam, a seer living by the banks of the River Euphrates whose curses were famous for their effectiveness.

But Balaam, faithful to the God of Israel, repeatedly refused, despite Balak's offer of a high fee. Then God appeared to him and commanded him to accept the fee and go, "but do only what I tell you to do."

Balaam set out on his donkey, but inexplicably God blocked the road. The donkey veered across the fields, squeezed his rider against a wall, and finally lay down. Balaam beat it with a stick to make it get up.

"What have I done to you that you have struck me these three times?" the donkey asked. "Am I not your donkey, which you have ridden all your life to this day? Have I been in the habit of treating you this way?"

An angel of God appeared and ordered Balaam to travel on and to obey his orders to the letter. At Balak's court the angel inspired Balaam with three oracles, all favorable to Israel, which Balaam repeated word for word. Balak was vexed and angry. Nonetheless, he let Balaam return home.

However, Balaam later turned from God and induced some Moabite women to have intercourse with some of the Israelite men who, influenced by their pagan concubines, began to worship the god Baal. For this offense Balaam was killed during Moses's later campaigns against the Moabites.

Hermann tom Ring
1521–1596
Balaam
Sankt Paul
Münster
Germany

Orietur stella ex Jacob et consurget Virga de
Israhel et percutiet duces Moab vastabitꝫ filios Seth.

The Crossing of the Jordan

When all who had left Egypt with him had died, Moses went to the top of Mount Pisgah, across the Jordan from the Promised Land. There God "showed him the whole land," and said, "I have let you see it with your eyes, but you shall not cross over there." Then Moses "died there in the land of Moab, at the Lord's command … but no one knows his burial place to this day."

The time had come for the holy people to enter the Promised Land. But there was the Jordan to cross, and in "the time of harvest," when "the Jordan overflows all its banks." Nonetheless, Joshua, worthy successor to the Moses of the Red Sea crossing, put his people in marching order behind the Ark of the Covenant.

The priests carrying the Holy Ark came to the river and entered its waters. Immediately the waves "flowing from above" became a solid wall, while downstream the river flowed on ceaselessly toward the Dead Sea. All Israel could now pass dry-shod. The priests escorting the Ark reached the west bank first, and when "the entire nation" was on dry land, upstream and downstream waters closed together and the river flowed as always.

Joshua then had twelve stones taken from the river and arranged into a monument on the bank, commemorating the occasion.

The first practical consequence of this major event was that for the first time in forty years manna stopped falling on the Hebrews' camp. A few days later, as the time for celebrating Passover had come, they ate the fruits of the land of Canaan.

Raphael
(Raffaello Santo or Sanzio)
1483–1520

*The Crossing of the
River Jordan*

Loggia of the Palazzi Pontifici
The Vatican
Rome

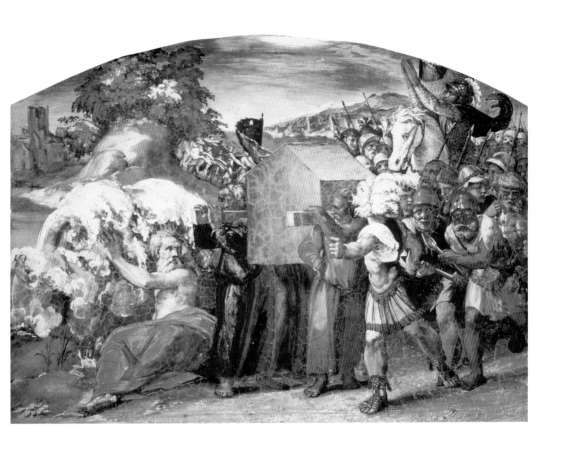

The Trumpets of Jericho

Jericho, the first city along the Hebrews' route through the Promised Land, seemed impregnable.

Following God's command, Joshua ordered a plan of attack that resembled a religious ceremony more than warfare. The Hebrews began to circle the city. Behind an armed vanguard came seven priests with ram's-horn trumpets; behind them came the Ark of the Covenant, with the majority of the troops and everyone else taking up the rear. Everyone maintained a profound silence except the priests, who blew continually on their trumpets.

The procession went around the city twelve times that day and twelve times a day for five days more. On the seventh day it went around Jericho only seven times. On its last cycle, "Shout!" Joshua cried. Everyone shouted and the walls of Jericho crumbled down.

Then Joshua uttered a solemn curse. "Cursed before the Lord be anyone who tries to rebuild this city—this Jericho! At the cost of his first-born he shall lay its foundation, and at the cost of his youngest he shall set up its gates!"

Much later, in Ahab's days, a certain Hiel took advantage of the then dominant impiety to rebuild Jericho, but at the cost of his first-born son, Abiram, and his youngest, Segub, as prophesied by Joshua.

Franz Joachim Beich
1665–1748

The Trumpets of Jericho

Städtische Galerie im Lenbachhaus
Munich
Germany

Joshua Stops the Sun

The conquest of the Promised Land was no easy matter; consequently Joshua's life as Moses's successor was one long series of battles. But throughout his campaign he benefited from the unstinting and decisive help of the Lord of Hosts.

At the Battle of Gibeon, which opened the way to the south and Palestine itself, he helped Joshua rout a coalition of five kingdoms, including Jerusalem and Hebron, by hailing large stones down upon the fleeing armies. The stones killed more men than did Joshua's troops. To prolong the rout so as to triumph over the Amorites, Joshua, "in the sight of Israel," prayed to God, saying, "Sun, stand still at Gibeon/ And Moon, in the valley of Aijalon." "And the sun stopped in midheaven" until the Amorites were slain.

A man holding out his arms is an essentially static image. Nicolas Poussin has made his image of Joshua small, placed it in the painting's distant background, and filled most of his canvas with a host of vivid figures of battling men. Nonetheless, by virtue of its placement both on the horizon and near the painting's top edge, the image of Joshua is as vivid, if not as engaging, as that of the battle scene. Thus Poussin honors both Joshua's divine, and his soldiers' human, role in the victory.

The event was retold in song on nineteenth-century southern American plantations by black slaves who reimagined it in terms of their own experience: "Joshua was the son of Nun,/ He never quit till his work was done."

Joshua had the five kings put to death and hung their bodies from the trees as an example. During his conquest of Canaan, thirty-one kings died at his hands.

Nicolas Poussin
1594–1665

Joshua's Victory over the Amorites

Hermitage
St. Petersburg
Russia

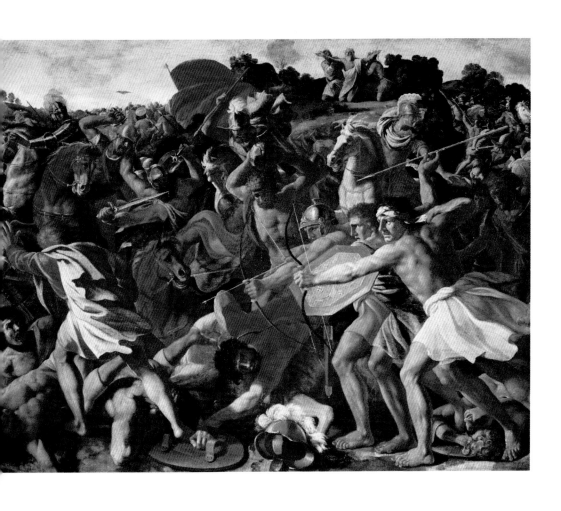

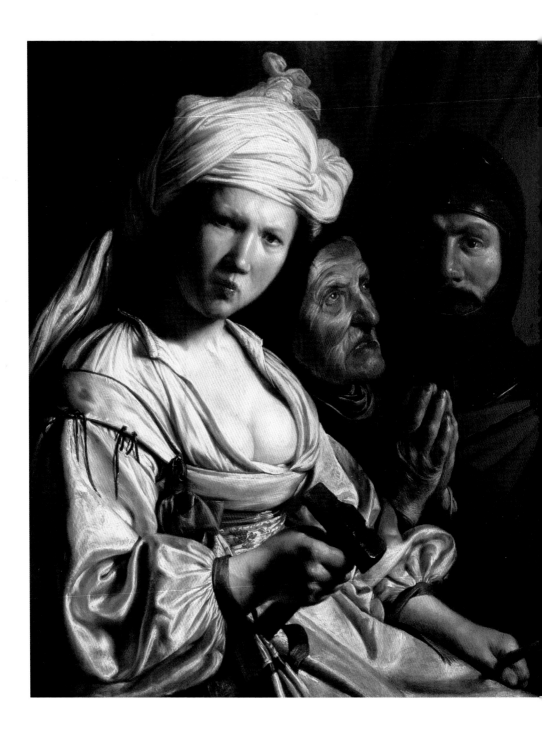

Barak and Deborah

Salomon de Bray
1597–1664

Jael, Deborah, and Barak

Catharijnconvent Museum
Utrecht
The Netherlands

After Joshua's death, the Israelites fell to idol worship. Rebellions and military losses followed, relieved by periods of sanctity and independence under the leadership of heroes and heroines called Judges.

When Israel was subjugated by the Canaanite king Jabin and oppressed for twenty years by his commander in chief Sisera with his "nine hundred chariots of iron," the prophetess Deborah moved her people to rebel and return to God.

She used to sit under a tree, known as the Palm of Deborah, between Bethel and Ramah in the hills of Ephraim, near Jerusalem. One day, without prompting from man or God, she summoned Barak from his home in Kedesh, far to the north. The Scriptures attributes no prior military distinction to him, but Deborah, speaking for "the Lord God of Israel," commanded him to raise an army of ten thousand and shake off the Canaanite yoke.

Barak accepted on condition that Deborah go with him. "I will surely go," she said, "but the road on which you are going will not lead to your glory, for the Lord will sell Sisera into the hands of a woman."

What followed confirmed this prediction but in an unexpected way.

Barak routed and annihilated the Canaanite army, but Sisera escaped. Alone and on foot, he reached the tent of Jael, wife of a nomadic king who, unbeknownst to Sisera, had broken with Jabin and come over to Israel's side. Jael greeted Sisera with feigned hospitality, pouring him milk to drink, giving him a bed in her tent, and agreeing to stand guard outside and tell no one he was there. But while he slept she stole into the tent and drove a stake through his temples into the ground. When Barak, tracking Sisera, came to her tent, Jael said only, "Come, and I will show you the man whom you are seeking."

As Deborah foretold, a woman vanquished Sisera, and Barak, victorious commander of ten thousand, received no credit for it.

Gideon's Army

To fight the Midianites, who were forcing their God Baal onto the Hebrews, the young man Gideon sent out a call to arms. Thirty-two thousand men answered it. God deemed that to win without risk was to triumph without glory; the army was too large for the victory to be called his.

He commanded Gideon to dismiss those ambivalent about battle. Twenty-two thousand men returned home, but God thought ten thousand still too many, so He told Gideon to lead his troops to a watering place.

"All those who lap the water with their tongues, as a dog laps," he said, "you shall put to one side; all those who kneel down to drink, putting their hands to their mouths, you shall put to the other side."

Almost everyone squatted down to drink more easily; only three hundred stayed erect, like true soldiers.

Gideon led his pathetic force into battle and returned victorious.

Johann Heinrich Schönfeld overcame the difficulty inherent in the depiction of a host of static, standing figures by emphasizing the kneeling and squatting soldiers in the foreground, painted in rich light and glowing colors. By contrast, the army of three hundred is represented by scores of tiny gray men waiting at attention in the far background. Yet insubstantial and even ghostly though they seem, they are the future of the painting's moment. It is they who will come back in the blazing light and vivid colors of victory. Schönfeld's contrasting handling of the two hosts is but one way painters incorporated the larger time scheme of an Old Testament story into a single moment, thus reminding the viewer of the whole episode while depicting only a single instant of it.

Johann Heinrich Schönfeld
1609–1682/83

Gideon Tests his Army

Kunsthistorisches Museum
Vienna

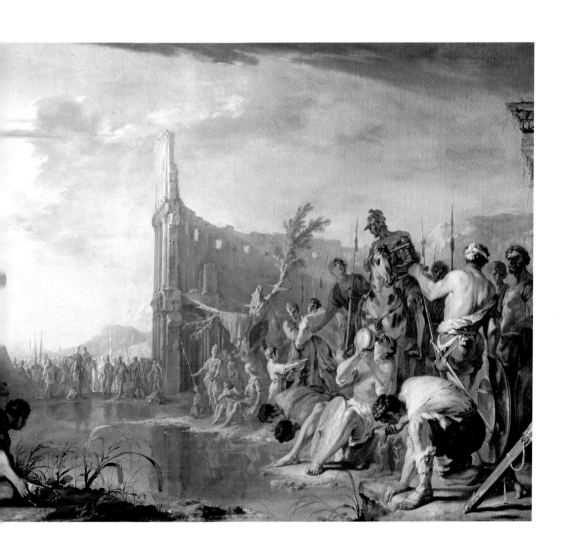

Jephtha's Daughter

Jephtha was a prostitute's son rejected by his community of Gilead. And so he became a brigand and led a band of thieves in the mountains.

When the Ammonites declared war against Gilead, the city's elders went to Jephtha's headquarters in the land of Tob and asked him to lead their troops, offering him not only military command but also civil rule. He accepted only on condition that "You bring me home again."

On the eve of battle Jephtha made a vow to God. "If you will give the Ammonites into my hand, then whoever comes out of the doors of my house to meet me, when I return victorious from the Ammonites, shall be the Lord's, to be offered up by me as a burnt offering."

When he came home covered with glory, his only daughter ran out to meet him, dancing to her tambourine. Overwhelmed, he tore his garments, but the vow had been made. Moreover, his daughter understood perfectly, and asked only a reprieve of two months to go into the mountains to "bewail my virginity, my companions and I." When she returned, her father gave her to God.

This is a biblical version of the Greek myth of Iphigenia, sacrificed by her father Agamemnon for the sake of his war against Troy. And just as it is claimed that Iphigenia was spared at the last minute and became a priestess of Artemis in the country of the Tauri, Jewish tradition has it that the great brigand's daughter survived as a virgin devoted to the worship of God. As the two stories are easily confused, there are depictions of one heroine that can stand for the other. However, the figure of a young maiden welcoming her astonished father to the sound of her tambourine can refer only to Jephtha's daughter.

Giovanni Francesco Romanelli
c. 1610–1662

Jephtha Sees his Daughter
Kunsthistorisches Museum
Vienna

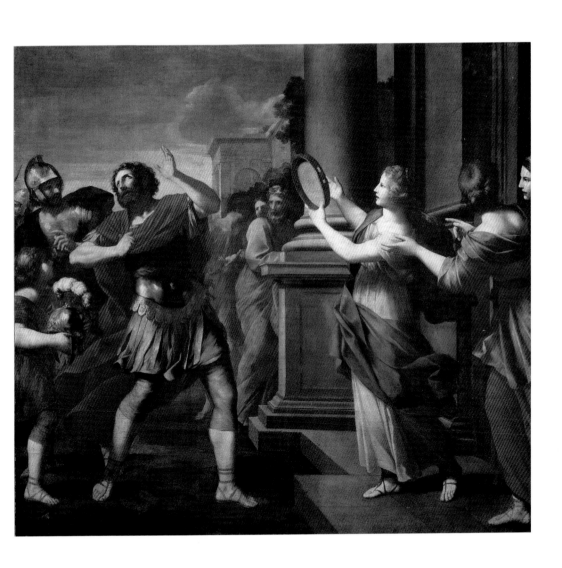

Samson and the Lion

Like many Old Testament stories, Samson's begins with a childless couple being promised a son in exchange for dedicating him to the Lord. The terms for Samson's parents were that he never eat grapes, drink wine or vinegar, or let a razor touch his hair. The restriction against the cutting of the hair was the source of Samson's superhuman strength, which in turn led to his mistakes and eventual redemption.

Despite his asceticism Samson fell in love with a Philistine woman and married her even though his parents objected to a match between their son and an idolater.

Shortly before the wedding, Samson was passing through a vineyard when a young lion roared at him. He charged at it and tore it to pieces. He thought nothing of this and told nobody. Passing by the same spot a few days later, he saw that a swarm of bees had lodged itself in the animal's carcass. The honey was very good, so at the wedding he posed a riddle to a group of thirty young Philistines:

Out of the eater came something to eat.
Out of the strong came something sweet.

He wagered thirty pieces of linen and thirty "festal garments." The men were baffled for three days and on the fourth they secretly told Samson's bride they would burn her house down if she didn't help them. She wheedled the answer out of Samson, but when the Philistines spoke it to him he had no doubts about how they got it, and said, "If you had not plowed my heifer, you would not have found out my riddle."

Still, he paid his debt. He went out and killed thirty other Philistines and stripped them of their clothes, which he sent to the wedding guests. Then he went straight to his parents' house.

The story is tangled, but the hand-to-hand combat with the lion has provided painters with a dramatic theme.

Francesco Hayez
1791–1881

Samson and the Lion

Galleria d'Arte Moderna
Florence
Italy

Samson and the Philistines

Believing that Samson had abandoned his wife, the bride's father gave her to the groomsman. Samson felt wronged. "This time," he said, "when I do mischief to the Philistines, I will be without blame."

He captured three hundred foxes and tied them together in pairs by their tails, then set a torch in each knot, lit them all, and released the foxes into the Philistines' harvest fields. The fields caught fire and burned to the ground, along with the vineyards and the olive trees, and Samson fled to the tribe of Judah.

Furious, the Philistines pursued him and forced his hosts to hand him over. Samson let himself be taken with good grace, but once among the Philistines he broke his bonds. Seeing the jawbone of a donkey lying on the ground, he snatched it up and attacked the Philistines with it, slaughtering a thousand. Then he went away, singing:

> With the jawbone of a donkey
> heaps upon heaps;
> with the jawbone of a donkey
> I have slain a thousand men.

Then, as Samson was thirsty, God transformed the donkey's teeth into a fountain.

Such an exploit by the biblical Hercules could not escape the painter's brush.

This was not Samson's last feat of arms. He had a pronounced weakness for pretty idolaters and went to the city of Gaza, the Philistine capital, and spent the night with a prostitute.

Learning that he was there, his enemies waited for him at the city gate. But as he went out of the city he took the gate off its hinges, put it on his shoulders, with its heavy double doors, its posts and enormous bolts, and carried it forty miles uphill to the mountain opposite Hebron.

PAGES 128–29

Jacopo Bassano
c. 1510–1592)

Samson Defeats the Philistines

Gemäldegalerie, Alte Meister
Dresden
Germany

Samson and Delilah

After the episode of the gates of Gaza, Samson fell in love with Delilah, from the valley of Sorek, about thirteen miles southwest of Jerusalem. The Old Testament does not say whether she was a Philistine or an Israelite. What is unambiguous, however, is that she was meretricious and that her greed was Samson's undoing.

After she became Samson's mistress, several Philistine kings asked her to discover the secret of Samson's strength and each promised her eleven hundred pieces of silver if she succeeded.

Three times Delilah pressed Samson and each time he lied, telling her to bind him with bowstrings, then with new rope, then to weave seven locks of his hair into the cloth on her loom. After each answer she bound him while he slept, but when the Philistines came for him he snapped the ropes with ease.

Finally, he told her the truth, that if his hair were cut he would lose his strength. She told the Philistines who came with the bribe and when Samson fell asleep one of their men stole into his bedroom and cut off seven locks of his hair.

When he awoke his strength was gone and he was in his enemies' hands. They gouged out his eyes, chained him, and sentenced him to turn a mill in the depths of a prison.

Samson's confrontation with the perfidious beauty and his ensuing impotent rage have inspired great artists, who, to accentuate the scene's dramatic nature, most often show Delilah cutting his hair herself.

Sir Anthony van Dyck
1599–1641

Samson and Delilah

Dulwich College
Picture Gallery
London

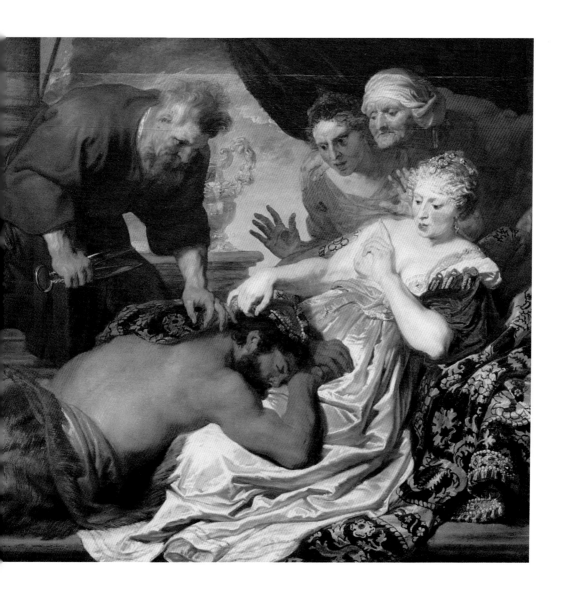

The Temple Pillars

To give thanks for their victory over Samson, who had so ravaged their land, the Philistines held a solemn sacrifice to their god Dagon and to his manifest superiority over God. After the ceremony, the people "made merry" and said, "Call Samson, and let him entertain us."

The blind fallen hero was led from his jail to the temple of Dagon and exhibited like a beast at a fair. But his hair had grown back, restoring his strength to him. Claiming to need rest, he asked the boy who had guided him from jail to lead him to the temple pillars so that he could lean against them. He tested the shafts, prayed to God, and with a sudden surge drew on all his strength, crying, "Let me die with the Philistines!"

The kings who had bribed Delilah went to their deaths with him, along with three thousand celebrants at the temple. And so Samson slew in that one day more Philistines than he had killed in all his previous exploits together.

Johann Georg Platzer
1704–1761

Samson's Revenge

Österreichische
Barockmuseum
Vienna

Ruth and Boaz

As famine reigned in Israel, a man named Elimelech left Bethlehem with his wife Naomi and two sons and settled in the land of Moab, across the Jordan. His sons married Moabites, Orpah and Ruth. About ten years later, father and sons were dead and Naomi was alone with her two daughters-in-law.

She decided to go back to Bethlehem and advised Orpah and Ruth to return to their respective parents and find new husbands. Orpah agreed. But Ruth, whose loyalty to Naomi was as great as Naomi's concern for her, said, "Where you go, I will go, and where you lodge, I will lodge. Your people shall be my people, and your God my God." And so they left together.

They arrived at Bethlehem during harvest. To survive, Ruth began to glean behind the reapers according to a right given to the poor.

The landowner Boaz noticed the young widow, encouraged her to glean his fields, and told her to drink from his servants' pitchers. Noticing this, Naomi remembered that Boaz was a relation of her dead husband; like him, he could enter into a levirate marriage, an institution authorizing (and sometimes obligating) a man to marry his widowed sister-in-law to secure offspring to his deceased brother.

At the end of the harvest, Boaz fell asleep at the foot of a heap of grain on his threshing floor. Following Naomi's advice, Ruth went discreetly to him and lay down at his feet. When he awoke and asked what she was doing there, she apprised him of their family relationship and all that it implied. Ruth and Boaz married and their son Obed was King David's grandfather.

Ruth and Boaz paintings gained popularity in mid-nineteenth-century France, possibly due to George Sand's novel *La Mare au diable*, (1846), which is about the love between a young farmer and a poor peasant girl and includes a long wedding scene rich in centuries-old rural customs, and Victor Hugo's poem *Booz endormi* (1853).

Gerbrand van den Eeckhout
1621–1674

Boaz and Ruth

Kunsthalle
Bremen
Germany

Samuel and Eli

When Samuel was quite young, his mother, Hannah, and his father, Elkana, consecrated him to the active service of God and sent him to live with the high priest Eli, in Shiloh, which was then the seat of the Ark of the Covenant.

Now Eli knew that God was of two minds about him. His own loyalty as priest found favor in God's eyes; nonetheless, God was meditating a curse upon Eli's house because of the sinfulness of his sons, also priests, by hereditary right. They had long been pilfering the offerings brought to the temple for sacrifice, and sleeping with the women who served in the inner sanctuary. Eli knew of all this and had reproached his sons for it many times, but was too old and weak to stop them.

Asleep in the temple one night shortly after he had joined Eli's household, Samuel was awakened by a voice calling his name. Thinking it was Eli summoning him, he ran to him. But Eli said he had not called and sent Samuel back to bed. Again the voice called and Samuel went to Eli just to be sent back once more. But the third time, Eli understood that God was calling the boy and told Samuel, "Go, lie down; and if he calls you, you shall say, 'Speak, Lord, for your servant is listening.'"

When the voice called again and Samuel answered it directly, God told him, "I will fulfill against Eli all that I have spoken … . For I have told him that I am about to punish his house forever, for the iniquity that he knew, because his sons were blaspheming God and he did not restrain them … the iniquity of Eli's house shall not be expiated by sacrifice offerings forever."

Samuel was afraid at first to repeat God's words to the priest, but Eli pressed him hard so that in the end he kept nothing back. The old man said simply, "It is the Lord; let him do what seems good to him."

Lambert Doomer
1624–1700

Hannah and Samuel before Eli

Musée des Beaux-Arts
Orléans
France

The Capture of the Ark

While Samuel was under Eli's care, war broke out between Israel and the Philistines. When the Philistines gained the upper hand, the Hebrews sent to Shiloh for the Ark of the Covenant "so that [the Lord] may come among us and save us from the power of our enemies."

The sound of the Israelites' rejoicing at the sight of the Ark coming among them startled the Philistines, and when they were apprised of the reason for it they were alarmed. "The gods have come unto the camp," they shouted, "who struck the Egyptians with every sort of plague in the wilderness." But they rallied. "Take courage and be men, O Philistines, in order not to become slaves to the Hebrews as they have been to you; be men and fight."

Unwittingly complying with God's plans, they regained the offensive, killing thirty thousand Hebrews. Then they seized the Ark, killing Eli's two sons, who had brought it from Shiloh, and took it off to their great city of Ashdod, on the Mediterranean, midway between Gaza to the south and Joppa to the north.

When the dreadful news came to Shiloh, old Eli fell down dead. Thus that which the Most High had foretold was realized.

Since the Middle Ages, painters have often depicted this battle scene, where the Ark is suddenly transformed from a mighty arm of the children of Israel into a spoil of war.

Gerrit Bleker
fl. 1625–1656

*The Capture of the Ark
by the Philistines*

Museum of Fine Arts
Budapest

The Plague of the Philistines

In Ashdod, the Philistines placed the captured Ark of the Covenant in the temple of their god Dagon, next to the idol itself.

The next morning the Philistine priests discovered the statue of Dagon fallen over, its face to the ground before the Ark. They placed it upright. The second day the statue was again on the ground, its head and hands cut off and lying far off on the temple threshold. Soon thereafter an epidemic of tumors broke out in Ashdod, causing many deaths—an illness that modern scholarship interprets as bubonic plague, frequent along the eastern Mediterranean in biblical times.

"The Ark of the God of Israel must not remain with us," the people cried. "For his hand is heavy on us and on our god Dagon." But the Philistine leaders weren't sure, so they moved the Ark inland to Gath. Plague broke out there, so the Ark was moved to Ekron, followed by the plague. The people of Ekron cried, "Send [it] away … to its own place, that it may not kill us."

The Ark was then put on a chariot harnessed with a pair of cows that had never been yoked and which had calves that had already been nursed. The beasts went away without complaining about their offspring and took the Ark to the territory of the Hebrews.

The plague of Ashdod appealed to Classical painters by virtue of the many instances it offers for the treatment of the theme of human suffering *en masse* through strong variations on the poses of kneeling, beseeching, and reclining sufferers—and, as in the case of the many falling and supine bodies in Poussin's painting here, for the strangeness of the inverted figure: poses inappropriate to most other biblical themes except warfare.

In the late nineteenth century Napoleon visited his sick and dying soldiers in the Plague House of Joppa, just north of Ashdod.

Nicolas Poussin
1594–1665

The Plague of Ashdod, or *The Miracle of the Ark*

Louvre
Paris

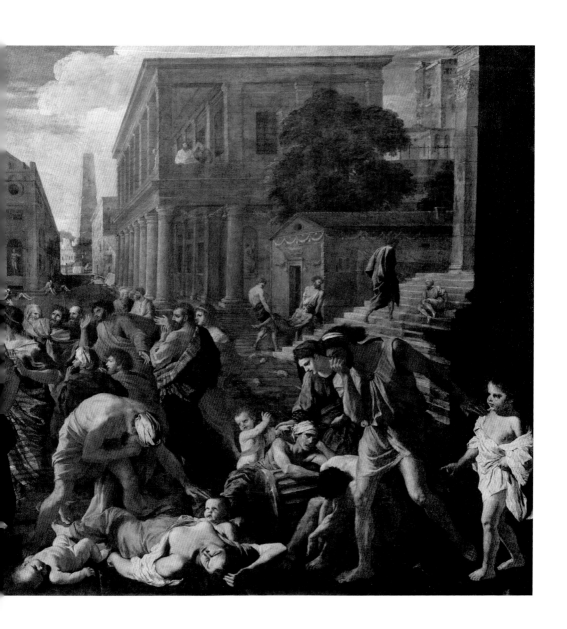

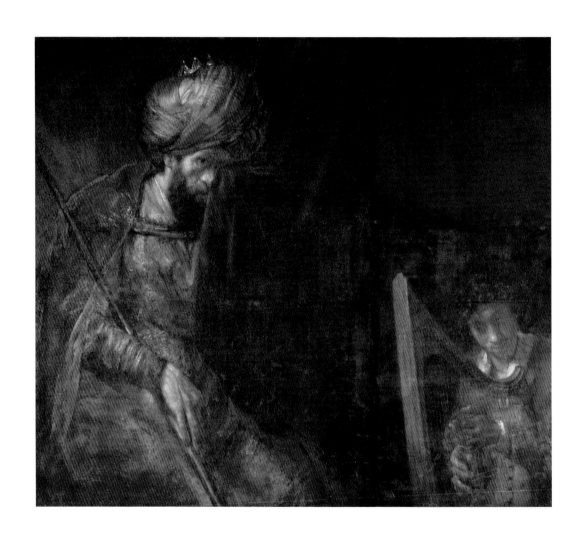

David and Saul

Rembrandt
(Rembrandt van Rijn)
1606–1669

David and Saul

Mauritshuis Museum
The Hague
The Netherlands

The adult Samuel, who mediates between God and the people but utters no prophetic vision, military advisor without a command, king-maker and counselor without power, is a transitional figure between the age of judges and that of kings and prophets.

It was from Samuel as judge that the Israelites sought guidance when they wanted a central ruler. When Samuel anointed Saul, authority shifted from the judgeship to the throne. At first he gave Saul good military advice and kept him in the ways of righteousness, but he was old and not always present at Saul's side.

In a war against the Philistines early in his reign, Saul disobeyed God's command as stated by Samuel. He won the battle but lost God's favor. Victory followed victory but transgression also followed transgression; Samuel's reproaches multiplied and Saul fell into a pattern of repentance and backsliding, tormented by remorse and fear. In secret, Samuel sought out David, son of Jesse of Bethlehem, and anointed him king.

To ease his torment, Saul asked for a harp player. His servants brought him David, whose playing soothed him. "Saul loved him greatly, and he became his armor-bearer … . And whenever the evil spirit … came upon Saul, David took the lyre … and Saul would be relieved … ."

After David's victory over Goliath, the Philistine giant, Saul became jealous of David, then suspicious, then hostile, and David began to live in fear, then fled the palace and led a fugitive's life. This tortured relationship has provided many themes for painters, but most have favored that of David at his harp soothing the troubled king.

David and Goliath

In antiquity and chivalric Europe warring armies sometimes entrusted their fate to the outcome of single combat between two champions or two small companies. We see this in literature in the *Iliad* and medieval *chansons de geste*. We see it once in the Old Testament in young David's combat with the Philistine champion Goliath.

At the battle of Socoh this giant of a man, standing nine feet tall and wearing armor weighing over one hundred twenty pounds, came out of the Philistine ranks and shouted across the field to Saul's army, "Choose a man for yourselves, and let him come down to me. If he is able to … kill me, then we will be your servants; but if I … kill him … you shall … serve us."

The shepherd David went out to meet Goliath without armor and carrying only a sling, a deadly weapon known in both camps but not for single combat. The stone flew, striking Goliath square in the forehead before he even drew his sword; he fell dead and the youth unsheathed the sword and beheaded him with it. The Philistines fled. Given a field commission by Saul, David carried the war into Philistine territory, slaughtered many and returned, victorious.

All along the army's way to Saul's home in Gibeah, near Bethlehem, "the women came out of all the towns of Israel, singing and dancing, to meet King Saul … . 'Saul has killed his thousands … and David his ten thousands.' So Saul eyed David from that day on."

Painters have always emphasized David's youthfulness. Titian's David retains some of childhood's plumpness, softness, and rosiness and his gesture is charged with childhood's spontaneity. One can imagine him as a model for these lines of an Afro-American spiritual:

Little David was a shepherd boy,
He killed Goliath and he shout for joy … .

Titian
(Tiziano Vecellio)
c. 1485/90–1490

David and Goliath

Santa Maria della Salute
Venice
Italy

David and Jonathan

After the death of Goliath, a profound friendship was born between David and Saul's son Jonathan, which saved David from Saul's wrath. For when Saul's jealousy of David's sudden popularity turned to fear of David as a potential rival, and then to rage, David had no ally but Jonathan.

One day, as David was playing his harp, Saul "raved within his house," and as he had his spear in his hand, he threw it at David, thinking, I will pin David to the wall. But David dodged the spear.

Saul then tried to use his daughter Michal as "a snare for him." He offered her to David as a wife, setting the bride's price at a hundred Philistine foreskins in the hope that David would be killed trying to get them. But David went out against the Philistines, came back with the foreskins, and married Michal. "When Saul realized that the Lord was with David, and that … Michal loved him, Saul was still more afraid of David." Henceforth his enmity was out in the open.

It was then that Jonathan came to David's aid. He tried to intercede between his father and his friend. When that failed, David, aided by Michal, fled the palace and went to Jonathan. The two swore eternal friendship and loyalty, and Jonathan returned to his father's house as David's spy. Shortly thereafter, he met secretly with him in the fields to warn him of a trap Saul was laying for him. David eluded it and became a fugitive. Jonathan visited him once, comforting him and reaffirming his loyalty and friendship, and "strengthened his hand against" Saul; that is, gave him material support. Saul led several expeditions against David, but the accounts of them do not name Jonathan as taking part.

Rembrandt
(Rembrandt van Rijn)
1606–1669

*The Parting of David
and Jonathan*

Hermitage
St. Petersburg
Russia

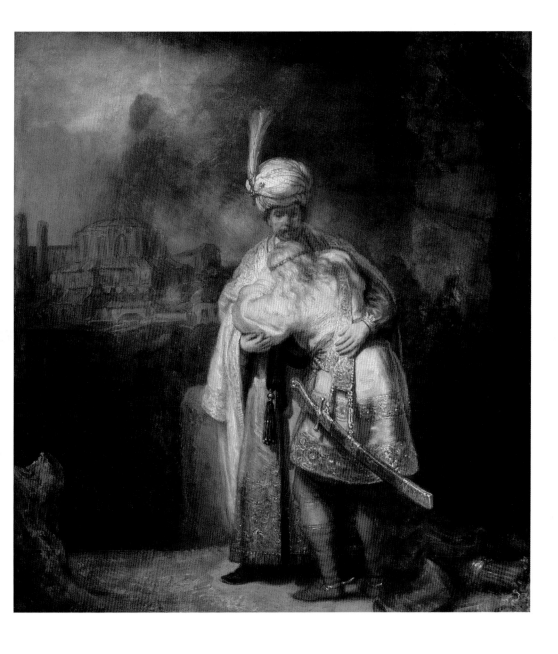

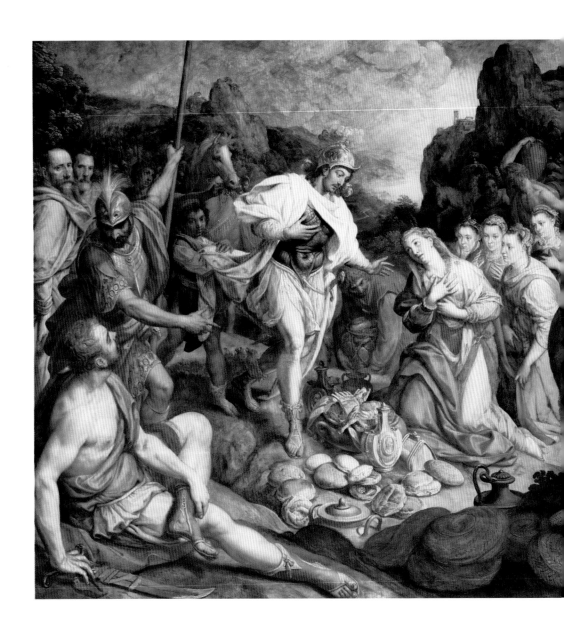

David and Abigail

David maneuvered in the north to avoid being captured by Saul without actually doing battle with him, lest he raise his hand "against the Lord's anointed."

One day, he sent a message to Nabal, a rich landowner of the region, requesting provisions for his small band of followers. But he left the size of the contribution up to Nabal himself. This was a liberal and courteous gesture in an era when foraging armies simply took what they needed, by force if necessary.

Nabal refused with the fiercely insulting reply, "Who is David? Who is the son of Jesse? There are many servants today who are breaking away from their masters. Shall I take my bread and my water and the meat that I have butchered for my shearers, and give it to men who come from I do not know where?" David could only take offense, and marched against Nabal with four hundred men.

When Nabal's wife, Abigail, heard of all this she understood the extent of the approaching catastrophe. Without a word to her husband, she hurriedly gathered "two hundred loaves, two skins of wine, five sheep ready dressed, five measures of parched grain, a hundred clusters of raisins, and two hundred cakes of figs" and went out to meet David. With a skillfully rhetorical speech she set forth the argument that taking revenge on a madman was unworthy of Israel's future king. Her eloquence and beauty persuaded him to turn back. Ten days later God struck Nabal dead. Without a moment's hesitation David married Abigail.

The story of David and Abigail was a popular theme in late sixteenth- and seventeenth-century painting, especially in the prosperous Netherlands, which delighted in images of abundant food, rich clothing, fine animals, and the other good things of life.

Frans Pourbus the Elder
1570–1622
David and Abigail
Kunsthistorisches Museum
Vienna

The Suicide of Saul

Saul pursued David intermittently for over a year. Not wanting to raise his hand against God's anointed, David contrived to elude battle when Saul came out against him. In between sorties he built up his army and consolidated his power. Twice he could have killed Saul, once when he was hiding in a cave where Saul went to relieve himself, and again when he stole into Saul's sleeping camp. Each time he cut a piece of Saul's cloak and, from a distance, called and showed him the cloth as proof that he had spared his life and that "there is no wrong or treason in my hands … ."

During this time, the Philistines attacked Israel. Saul led his army out, but in great anguish, knowing himself abandoned by God. One night he disguised himself, stole out of camp, and visited the Witch of Endor to know his fate.

The witch summoned the ghost of Samuel, who told Saul, "The Lord has torn the kingdom out of your hand, and given it to your neighbor, David … tomorrow you and your sons shall be with me: the Lord will also give the army of Israel into the hands of the Philistines."

Saul courageously met the Philistines at Mount Gilboa. His army fell around him and Jonathan and his brothers died. Wounded in the stomach, Saul called to his armor bearer, "Draw your sword and thrust me through with it, so that these uncircumcised may not come and thrust me through, and make sport of me." The terrified servant didn't dare, so Saul threw himself on his sword and died.

"Your glory, O Israel, lies slain upon your high places!" David sang when he received the news. "How the mighty have fallen! Saul and Jonathan, beloved and lovely … swifter than eagles … stronger than lions … . I am distressed for you, my brother Jonathan; greatly beloved were you to me; your love was wonderful, passing the love of women."

Johann Heinrich Schönfeld
1609–1682/83

The Death of Saul

Braith-Mali Museum
Biberach an der Riss
Germany

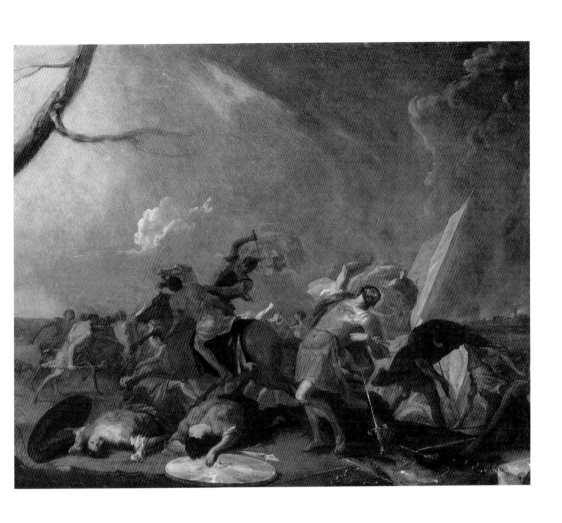

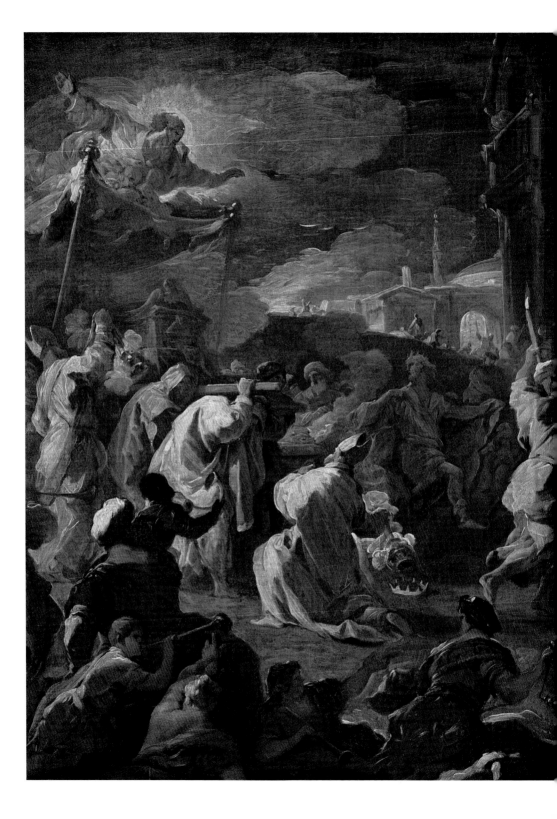

David and the Ark

Luca Giordano
1634–1705

*David Bringing the Ark
to Jerusalem*

Kunsthistorisches Museum
Vienna

After Saul's death, the people of the southern realm of Judah anointed David king at the holy city of Hebron. But Saul's son Ishbaal, king of the northern realm of Israel, opposed him. David's commander in chief Joab eventually defeated the house of Saul and David was anointed king of all Israel, again at Hebron. Seven years later he secured his power and crowned his glory by taking Jerusalem from the Jebusites and making it his capital. It later came to be called "The City of David," and "Zion," after the stronghold of Zion, which David took in order to win the city.

To manifest his new capital's sacred nature, David ordered the Ark of the Covenant brought up from Baale-judah. A chariot was built and oxen harnessed to it, and it was sent on its way to the sound of lyres, tambourines, sistrums, and cymbals. When the the procession stopped at Nacon, the oxen shook the Ark. The ox driver, Uzzah, reached out to steady it and God's lightning struck him dead. "How can the Ark of the Lord come into my care?" David asked, and lodged it in the house of Obed-edom.

Three months later, David learned that "The Lord has blessed Obed-emon and all his household," and the procession set out again.

All the way from Nacon to Jerusalem, David, dressed in the priestly garment of a simple linen apron, walked before the Ark, whirling and gambolling. Saul's daughter Michal, one of David's wives, was outraged by behavior she deemed unworthy of a sovereign. David said, "It was before the Lord that I have danced … . I will make myself yet more contemptible than this." Childless before, "Michal the daughter of Saul had no child to the day of her death."

The procession, at once solemn and lighthearted, served as a model for Christian processions, which, in turn, have inspired the depictions of the Ark's entry into the Holy City.

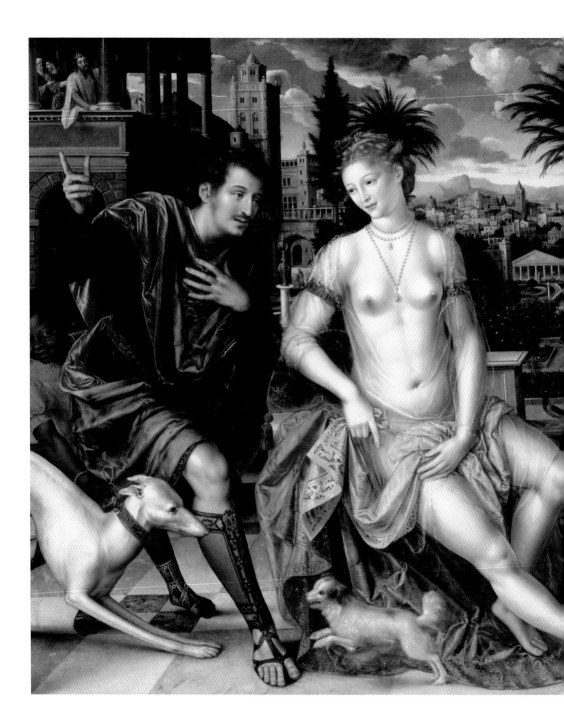

David and Bathsheba

From a high terrace, King David saw his neighbor Uriah's wife Bathsheba naked in her bath and fell in love. As Uriah, one of his generals, was out campaigning, David had Bathsheba brought secretly to his palace. Soon she became pregnant.

Wanting to avoid scandal, David found a pretext for giving Uriah furlough in Jerusalem, hoping he would sleep with Bathsheba and so be thought the unborn child's father. But Uriah slept at David's house, saying, "The Ark and Israel and Judah … and my lord Joab and the servants of my lord are camping in the open field; shall I then go to my house, to eat and to drink, and to lie with my wife?" David sent him back to the armies with sealed orders to Joab to put Uriah in a place of peril in the next battle. Joab obeyed, Uriah fell, Bathsheba performed a proper mourning, David waited a proper time, then he and Bathsheba were wed.

God was vexed and caused the child to die and did not pardon David and Bathsheba until the birth of Solomon, their second child.

Bathsheba at her bath was a much-loved theme of fifteenth- and sixteenth-century painters and their patrons.

Jan Massys
c. 1509–1575

David and Bathsheba

Louvre
Paris

The Death of Absalom

David's son Amnon raped his half-sister Tamar. To avenge her, her full brother Absalom had Amnon assassinated and fled Jerusalem. On Joab's advice David pardoned him.

Absalom was the most handsome and seductive man in Israel, but also the most ambitious. On his return to Jerusalem he began to plot, gathering support among the twelve tribes. Once his party was formed and in place, he had himself proclaimed king at Hebron.

The coup d'état was well executed. David, fearing capture in Jerusalem, fled the city, which fell to the traitor. To make it very clear that he was David's successor, Absalom took his father's concubines to himself.

Fighting back, David won the east bank of the Jordan and it was there that the final battle took place. David won the day and it was Absalom's turn to flee. David had ordered his officers to deal gently with Absalom, but Joab pursued him and caught up with him when, passing beneath a tree, Absalom had been stopped there, his abundant hair tangled in the low branches. Disregarding David's orders, the old soldier sank three spears into the undefended fugitive's body.

David didn't dare punish Joab, but on his deathbed he advised his successor Solomon to eliminate him. Solomon promised himself to kill off his father's remaining partisans and had Joab assassinated.

Painters have fastened on the confrontation between two highly distinctive characters: the ambitious young prince and the king's old soldier, loyal until this disobedience.

Giovanni Battista Viola
1576–1622

Joab Killing Absalom

Louvre
Paris

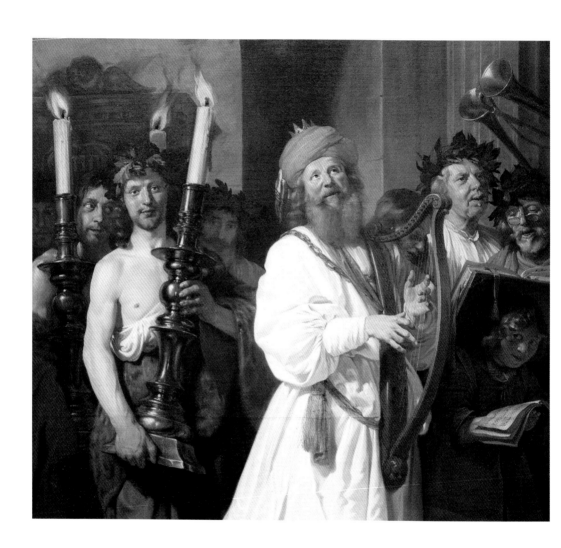

David Singing the Psalms

Jan de Bray
c. 1627–1697

David Playing the Harp

Gosford Castle
Markethill
Northern Ireland

In Renaissance Europe, David became the model of the courtly, literary prince, for this king, God's blessed warrior, was also a musician and a poet. About half of the psalms are attributed to him.

The purpose of the psalms is ambiguous. The word itself means "hymn," indicating that the psalms were songs in praise of God to be sung during religious observances. But after the section attributed to David the text reads, "the prayers of David are ended." And so they were also prayers.

Christianity has incorporated the complete Psalter, as the Book of Psalms is often called, into its liturgy, so that the collection can rightfully be called the voice of the Church.

The psalms have moved poets of many ages and countries to translate and adapt them into their respective languages. Notable adaptations are by the sixteenth-century French poet Clément Marot, protégé of François I, and the early eighteenth-century English poet George Watts. Composers, too, have been drawn to them. J.S. Bach used them for the texts of many of his weekly church oratorios. George Frideric Handel, composer of probably the best-known Christian oratorio, the *Messiah*, was drawn to psalms that feature sound, God's voice, the noise of storms and violent cataclysm, and music, as in Psalm 96, with the lines, "O sing unto the Lord a new song! O sing unto the Lord, all the whole earth," and "Let the heavens rejoice, and let the earth be glad, let the sea make a noise, and all that therein is."

The author of these prayers, which Christians knew by heart for centuries and which were always spoken during Mass and Offices, was an almost obligatory subject for Christian painters.

David and Nathan

David's reign represents both the complete transfer of power from the judgeship to the throne and the simultaneous transformation of the judges into prophets. The change begins with the judge Samuel's anointing Saul king and himself taking a secondary role in the kingdom's affairs. The transition is completed in the figure of Nathan, who stands in relation to David as Samuel stood to Saul. He is at David's side throughout his reign, but solely as David's religious conscience.

Once established in Jerusalem, David dreamed of building a temple to lodge the Ark of the Covenant. But God spoke to him through Nathan, saying, "When your days are fulfilled and you lie down with your ancestors, I will raise up your offspring after you, who shall come forth from your body, and I will establish his kingdom. He shall build a house for my name, and I will establish the throne of his kingdom forever." So David ceded the glory of constructing the Temple to Solomon.

When the king lusted after Bathsheba and had her husband, Uriah, killed, it was Nathan who intervened and urged repentance.

Yet at the end he acted politically. As David was dying he joined forces with Bathsheba to persuade the king, almost on his deathbed, to appoint Solomon successor.

He has therefore become a model of the saintly but political prelate, confessor or counselor to princes and kings.

Palma the Younger
(Jacopo Palma)
c. 1548–1628

*The Prophet Nathan
Admonishes King David*

Kunsthistorisches Museum
Vienna

The Judgment of Solomon

Two prostitutes who lived together gave birth at almost the same time. One of the children died. Its mother took the living child from its bed and put her dead child in its place. In the morning a quarrel broke out, each mother claiming the living child to be hers. The dispute eventually came before David's son and successor Solomon, known for his wisdom.

Solomon called for a sword and when it was brought he said, "Divide the living boy in two; then give half to the one, and half to the other."

Terror-stricken, the true mother said that the child should be given to her companion, who, by contrast, approved of Samson's judgment. By their reactions, Solomon knew the truth and gave the baby to its real mother, and all of Israel praised his wisdom.

This story takes up only thirty lines of the Old Testament. Its extraordinary popularity is echoed by the abundance of paintings dedicated to it.

Valentin de Boulogne
1591–1632

The Judgment of Solomon

Louvre
Paris

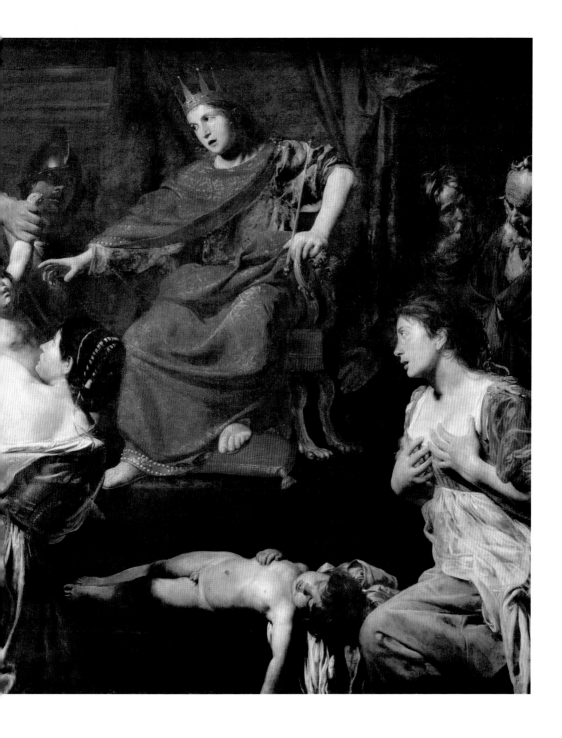

The Construction of the Temple

To lodge the Ark of the Covenant, Solomon took up the construction of the temple previously conceived by his father, David. The work lasted seven years and required some two hundred thousand paid workers and slave laborers under thirty-three hundred foremen and supervisors.

It was an international project. Each year, Solomon sent Hiram, king of the Phoenician city of Tyre, seven million kors (740 million gallons) of wheat and 700,000 kors (74 million gallons) of oil. In exchange, Hiram sent Libyan cedar and cypress wood, which was shipped by sea in convoys of rafts. He also provided artisans, chief among them being his namesake the bronze smith Hiram, who is thought to be the architect of the Temple.

The building was about eighty-nine feet long, sixty-six wide and ninety-eight high. The whole interior was lined with boards of carved cedar overlaid with gold leaf. Surrounded by adjoining buildings, the monument was at the end of three courts: the court of the Gentiles, open to non-Jews; the court of the Hebrews; and the court of the Levites, which held the altar. Within the courts a "molten sea" (a bronze pool also called the Sea of Bronze) "stood on twelve [bronze] oxen, three facing north, three facing west, three facing south, and three facing east … . Its thickness was a handbreadth; its brim was made like the brim of a cup, like the flower of the lily; it held two thousand baths." Inside, a hall lodging the seven-branched candelabra, the golden table, censers, and other liturgical objects stood before the Holy of Holies, the inner sanctuary, which only the high priest could enter, once a year, to anoint the Ark of the Covenant.

The description of the Temple is at once minutely detailed and vague, allowing many interpretations. Imaginative reconstructions by artists show an extreme diversity.

Jean Fouquet
c. 1415/20–*c.* 1481

*The Construction of
Solomon's Temple*

Bibliothèque Nationale
Paris

aud en ainsi de quan
tes uertus et de quants
biens il a este auctur
a ceulx de sa lignee. et
combien plain de grant aige il est
mort nous lauons declaire ou li

ure deuant dit. Quand salomõ
son filz: aucores ieune enfant eut
prins le royaume de son pere. et fu
assis ou siege royal. tout le peuple
solennelment faueur. comme on
seult faire a ung roy au commencé

Solomon and the Queen of Sheba

Solomon's kingdom extended as far as the Red Sea port of Eilat. From there, his fleet, constructed and manned by King Hiram of Tyre's Phoenicians, sailed to Ophir. Each expedition lasted two years and brought back close to a ton and a half of gold, jewels, and precious wood.

No one knows the site of this ancient Land of Cockaigne. Some say Arabia, others the east coast of Africa, still others think the island of Zanzibar, and some locate it even farther east, on the Indian coast, or in Sri Lanka, or as far as Sumatra.

Israeli power in the Red Sea was well enough established for the coastal kingdoms to seek political and commercial alliances. It is in this context that the Queen of Sheba came to Jerusalem from her historical land located in today's Yemen, on the Gulf of Aden between the Red Sea to the west and the Arabian Sea and Indian Ocean to the east.

The visit was a duel of munificence between the two sovereigns. The Queen of Sheba arrived with a caravan full of gold, spices, and precious stones. Nonetheless, she was overwhelmed by Solomon's palace, his table, his courtier's clothes, and the grandeur of his sacrifices to God. When she left, Solomon loaded her with more gifts than she had brought.

Jan de Vries's painting focuses less on the monarchs than on the splendor of the Queen of Sheba's retinue and King Solomon's court. The theme also allowed him to express his imaginative vision of the Temple, based on his own era's architecture of splendor.

Jan de Vries
(Hans Vredeman de Vries)
1527–?1606

King Solomon and the Queen of Sheba

Pushkin Museum of Fine Arts
Moscow

Elijah and the Ravens

After Solomon, Israel was torn by years of political and religious strife. The unified nation created by David and held together by Solomon split again into the northern and southern realms of Israel and Judah, which warred against each other and were racked by internal rebellion. Their kings married idolatrous foreigners and tolerated, encouraged, or professed paganism. It was during this time that the oppositional figure of the prophet arose. Unlike Samuel and Nathan, who spoke privately to their kings, the prophets spoke out publicly against them, often to their faces.

The first great prophet was Elijah, the only one to be honored by Chronicles as a character with a strong, sustained, active role in political and religious affairs.

Fifty years after Solomon's death, Ahab, King of Israel, married the Phoenician Jezebel and raised an altar to her god Baal and sacrificed to idols. It was then that Elijah emerged and told Ahab that his impiety would be punished by drought and famine. God then told Elijah to flee to the desert, where ravens would bring him bread and meat morning and night.

Hoping to end the drought, Ahab agreed to a confrontation on Mount Carmel between God and Baal. Altars were built to Baal and God, then all waited for the fires to be lit by divine hands. When Baal's altar did not catch fire, Elijah cruelly mocked the pagan priests. Then he prayed, and God's altar burned to ashes. At Elijah's word the people of Israel slaughtered four hundred fifty priests of Baal, whereupon a cloud appeared over the sea and grew progressively larger as it approached, then rain fell at last on the Promised Land.

However, Jezebel threatened Elijah with death and he fled to the wilderness around Mount Horeb. He was close to despair when an angel of God appeared to him and, without the ravens' intercession, brought him a pitcher of water and "a cake baked on hot stones."

Russian Icon
XVII CENTURY
The Prophet Elijah
Private Collection
Frankfurt
Germany

The Widow of Sarepta

During the drought and before the contest of the altars, God told Elijah to leave his refuge in the desert and stay with a widow at Sarepta, along the Phoenician border between Tyre and Sidon.

When he arrived at the widow's house he asked her for something to eat. All she had, she said, was a little flour and oil, just enough for one last meal for her and her son before they died of hunger. Nonetheless, she fed Elijah. From then on, her bin and pitcher never ran out of flour and water.

Some time later her son fell sick and died. Elijah took the body, carried it up to his room, and lay down by it, praying to God. His cries were heard and God restored the child's soul to his body. Elijah then went downstairs to the poor woman and said, "See, your son is alive."

This resurrection foreshadows those that Jesus was to effect; hence its importance in the tradition of Christian iconographic painting.

Bernardo Strozzi

1581–1644

The Prophet Elijah and the Widow of Sarepta

Kunsthistorisches Museum
Vienna

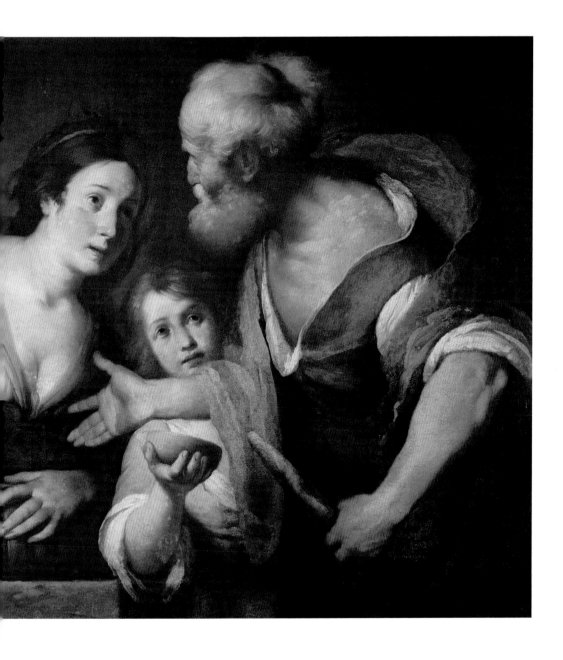

Elijah, Ahab, and Jezebel

Ahab and Jezebel coveted the vineyard of their neighbor Naboth, a noble of Ahab's royal city of Jezreel, and offered him a very high price for it. When Naboth refused they hired false witnesses and accused him of blasphemy and sedition before a meeting of his peers. He was found guilty and stoned to death.

Inspired by God, Elijah went to Ahab and Jezebel and predicted God's punishment. To Ahab he said, "In the place where dogs licked up the blood of Naboth, dogs will also lick your blood." To Jezebel his words were even more violent. "The dogs shall eat Jezebel within the bounds of Jezreel."

The curse on Jezebel came true, inspiring Racine, in his tragedy *Athalie*, with this vision of her end: "… a horrible mess of bones and slaughtered flesh dragged through the mire, bloody shreds and hideous limbs fought over by ravenous dogs … ."

But Ahab repented. And God, magnanimous, spared him while he lived and annihilated his royal line after his son's accession to the throne.

Lord Frederic Leighton
1830–1896

Elijah Pronounces the Divine Punishment to Jezabel and Ahab

Scarborough Borough Council
England

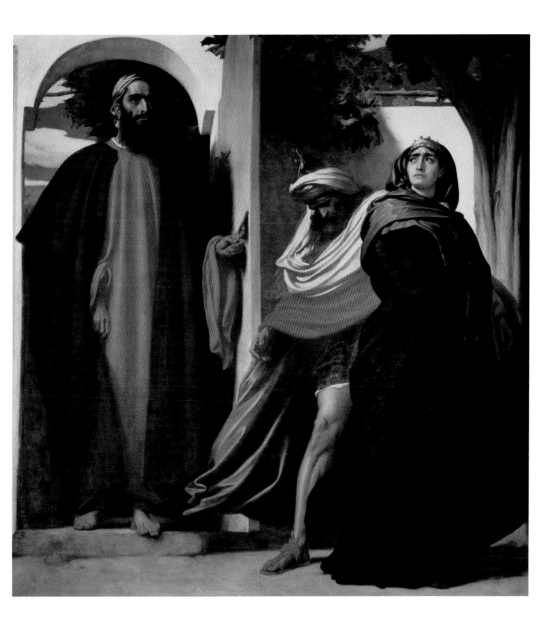

Elijah in the Chariot of Fire

In his old age, knowing that God was to take him up to heaven in a whirlwind, Elijah journeyed with his disciple Elisha to the appointed spot across the Jordan. Several times along the way he advised Elisha to leave him, but he would not. At the Jordan, with a power equal to that of Moses at the Red Sea, Elijah parted the river and the two men crossed it on the dry path.

As they conversed on the other side, a chariot of fire, harnessed to horses of fire, came down from the sky and the great prophet, Moses's peer, mounted it and ascended to the kingdom of God. All that remained of him on earth was his cloak, a gift to Elisha and the relic and symbol of the prophetic powers handed down to him. Hence our expression, "wearing," or "receiving the mantle of," for successors of great men.

Elijah's ascension is evoked in the last two stanzas of the nineteenth-century English poet William Blake's *Jerusalem*:

Bring me my Bow of burning gold!
Bring me my Arrows of desire!
Bring me my Spear! O clouds unfold!
Bring me my Chariot of fire!

I will not cease from Mental Fight,
Nor shall my Sword sleep in my hand,
Till we have built Jerusalem
In England's green and pleasant land.

Anonymous

The Ascension of the Prophet Elijah

Galleria Doria Pamphili
Rome

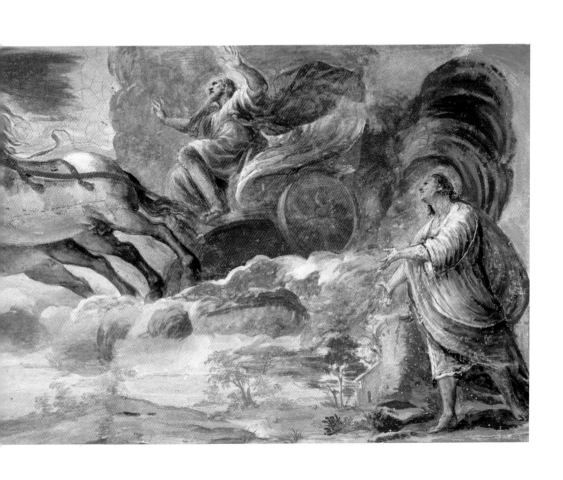

Elisha and the Shunammite

Elisha was a worthy successor to Elijah with respect to miracles.

He performed two for the wife of a rich landowner of Shunam (or Sunam), who had welcomed him to her home and had even had an oratory built for him on her estates.

First, he told her that she would have a son despite her husband's old age. "No, my lord, O man of God: do not deceive your servant," she said when he foretold the happy event.

She did indeed bear a son, but when he later died she hurled these words at the prophet, "Did I not say, Do not mislead me?"

Like Elijah before him, Elisha took the child to his room, lay down over him, and, by his prayers to God, made the breath come back to the child's lips.

Later, because of famine, the woman left the region and went to live among the Philistines. Seven years later she returned with her son and appealed to the king for the restoration of her lands. The king was just then having the deeds of Elisha retold to him and, enchanted to meet the heroes of such a miracle, gave her all she asked.

Gerbrand van den Eeckhout

1621–1674

Elisha and the Shunammite Woman

Museum of Fine Arts
Budapest

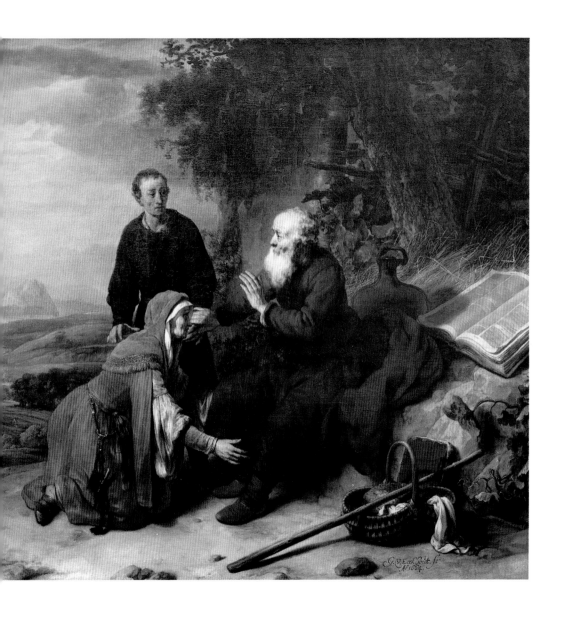

The Healing of Naaman

Namaan, a gifted soldier and general of the Syrian army, had leprosy. One day a little Israelite girl, who had been abducted by the Arameans and put in service to the general's wife, told him that she was sure that a prophet in her own land, who had performed miracles in Samaria, would know how to cure him.

Namaan got leave from his king and went to the king of Israel. Not knowing the name of the prophet he was seeking, he begged the cure from the king himself. The king of Israel was embarrassed by this request, beyond his powers to grant, and asked if the Syrians weren't using it and his inevitable refusal as a pretext for declaring war.

Fortunately, Elisha appeared and told Namaan, "Go, wash in the Jordan seven times, and your flesh shall be restored and you shall be clean."

Naaman was greatly annoyed that the holy man had not invoked God or even taken the trouble to lay hands on him. He left the palace in a rage, muttering that the rivers of Damascus were every bit as good as the Jordan's waters. But his subtle servants brought him to his senses with, "Father, if the prophet had commanded you to do something difficult, would you not have done it? How much more, when all he said to you was, 'Wash, and be clean'?"

And so Naaman washed himself in the Jordan seven times and came out of the river healed. Convinced of God's power, he asked to take some of the soil of Israel back with him so that his future sacrifices might be performed on holy ground. He also asked Elisha if he could still bow down with his king before the Syrian idols without failing in his duty to the one God.

Elisha said, "Go in peace."

Cornelis Engebrechtsz.
1460/65–1527

The Prophet Elisha Cures the Syrian Commander Naaman of Leprosy in the River Jordan

Kunsthistorisches Museum
Vienna

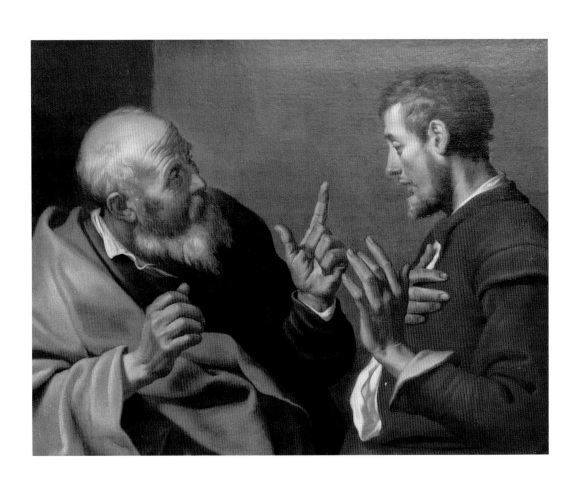

Elisha and Gehazi

Lambert Jacobsz.
c. 1598–1636

Elisha and Gehazi

Niedersächsische
Landesmuseum
Hanover
Germany

The character of Elisha's servant Gehazi (or Giezi) is a biblical prototype of literature's wily manservant essentially loyal to his master but out for himself, like Molière's Sganarelle or Beaumarchais's Figaro.

When his master refused the gifts of the Syrian general Naaman, whom he had cured of leprosy, and converted, Gehazi reasoned to himself that the prophecy trade was being undermined. Without a word to Elisha he ran after Naaman and swore to him that Elisha had just received a visit from two young men whom he had to entertain and needed a talent of silver and some clothes.

The generous Naaman gave him two talents and the clothing and Gehazi went back to his master, who asked him where he had been. Gehazi skillfully tried to avoid answering, but it does no good to lie to a prophet. Elisha said, "Is this a time to accept money and to accept clothing, olive orchards and vineyards, sheep and oxen, and male and female slaves? Therefore the leprosy of Naaman shall cling to you, and to your descendants forever."

But he apparently pardoned Gehazi later, for the next time Gehazi appears in the stories of Elisha he is standing before a king and queen, boasting of his master's miracles.

Lambert Jacobsz. has imagined a Gehazi more penitent than crafty. Also, although the painter placed the prophet and his servant far apart, as befits a scene of chastisement, he has placed Gehazi's hand just slightly in front of Elisha's, so that the two hands, which do not touch physically in the picture's imagined space, touch visually in the painting's design. This slight, virtual touch unites the men in their humanity if not with respect to their roles in the story. Thus the painting achieves its universality. It could be a scene of rebuke, or counsel, or instruction, between mentor and student, between an older and a younger friend, or between father and son.

Athaliah in the Temple

Athaliah, daughter of Ahab and Jezebel and mother of King Ochozias of Judah, learns of the deaths, one after the other, of her mother, her brother the king of Judah, and her son, and the slaughter of seventy of her father's kin.

In revenge, she slaughters in turn her son's children—her own grandchildren—so as to wipe out the line of David. One grandchild survives, the infant Joash, hidden in the Temple by Josabeth, wife of the high priest Joad.

His survival is kept secret for six years. In the seventh year, the priest Jehoiada mounts a coup d'état to depose Athaliah and place the young Joash on the throne. Warned, Athaliah goes to the Temple, where the plotters seize her and, not to profane the sacred place, drag her outside to kill her by the horses' entrance. The seven-year-old Joash is crowned and the people rededicate themselves to God.

The atrocities did not stop. During his forty-year reign Joash tolerated idol worship, misused Temple funds, let the Temple fall into disrepair, and turned from God. In the end he was struck down by one of his own men.

With respect to its bloodiness, the working out of a curse on a royal line over time, and the horror of infanticide, the story of the house of Ahab is an Old Testament counterpart of the Greek myth of the House of Atreus. The discursive, interrupted Old Testament narrative was given Classical order and clarity by the French playwright Jean Racine, whose earlier plays had been based on Classical Greek tragedy, and who came out of a twelve-year retirement to write two tragedies based on Old Testament themes. The success of the second, *Athalie* (1691), inspired painters, and Athaliah paintings began to appear in numbers.

Antoine Coypel
1661–1722

*Athaliah is Driven out
of the Temple*

Louvre
Paris

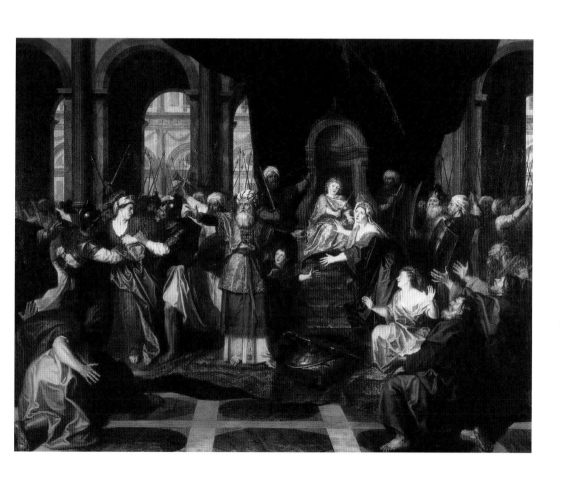

The Siege of Jerusalem

We must reckon with three sieges of Jerusalem by two kings named Nebuchadnezzar. Nebuchadnezzar I of Nineveh invaded Palestine around 660 B.C. However, he had to relinquish his conquests after the death of his general Holofernes. Nebuchadnezzar the Great of Nineveh and Babylonia, who ruled from 605 to 562, first captured the Holy City in 605, exiled its population and its king, Joachim, and set his uncle Sedecias on the throne.

When Sedecias rebelled, in 587, Nebuchadnezzar began a siege that is said to have lasted a whole year. When Jerusalem finally fell, Nebuchadnezzar leveled it and the Temple, had Sedecias's eyes put out, and sent the rest of the population into exile.

Jerusalem was taken so often during the centuries accounted for by the Old Testament that in some passages it is difficult to say precisely to which siege the Scriptures are referring.

In the Roman era, Caesar's rival Pompey took Jerusalem in 64 B.C., Titus ravaged it in A.D. 70, and in A.D. 130 it fell to Julius Severus. It was also taken by the Persians, the Saracens, and the Seljuk Turks, and captured by Gedefroy de Bouillon and the Crusaders in 1099. In a letter to Pope Paschal II, Godefroy and his companions describe the taking of the city thus:

> after the army had suffered greatly … the bishops and the princes ordered that all with bare feet should march around the walls of the city … on the eighth day after [this] humiliation [God] delivered the city … to us. It was the day indeed on which the primitive church was driven thence, and on which the festival of the dispersion of the Apostles is celebrated … . And if you desire to know what was done with the enemy who were found there, know that in Solomon's Porch and in his temple our men rode in the blood of the Saracens up to the knees of their horses.

Anonymous
Illuminated manuscript of the Bible
1390–1399

Nebuchadnezzar Lays Siege to Jerusalem

The British Library
London

Judith and Holofernes

Lucas Cranach the Elder
1472–1553
Judith and Holofernes
Kunsthistorisches Museum
Vienna

In Western painting, Old Testament warfare is an epic theme involving the clash of huge armies. Individual feats of arms are but details. But paintings of David and Goliath and Judith and Holofernes concentrate on the beheader and beheaded. On the former's face, the awareness of victory; on the latter's, agony and the shock of defeat.

Depending on which edition of the Bible one reads, the Book of Judith is either canonical or apocryphal. Legend dates the episode to around 660 B.C.

Nebuchadnezzar I, king of Assyrian Nineveh, sent his general Holofernes out to "march against all the land to the west" with twelve thousand cavalry and one hundred twenty thousand infantry.

Tyre, Damascus, and all kingdoms from Cilicia in Asia Minor far into Arabia submitted or were annihilated. Only the Hebrews of Judah resisted, setting up their defense in the fortified city of Bethulia.

Holofernes besieged Bethulia, cutting off its food and water supplies. When its starving inhabitants were on the verge of surrender, a young widow, Judith, conceived a deed that, she said, would "go down through all generations of our descendants."

Richly attired, perfumed, and bejeweled, she went with a servant to the Assyrian camp, claiming to have a plan for taking Bethulia. Struck by her beauty, Holofernes feigned courtesy, gave her her own tent and bided his time. But four days later he told a servant, "If we do not seduce her she will laugh at us," and invited her to a banquet in his tent.

Holofernes drank himself drowsy and lay down to rest. His guests filed out. Seeing him asleep, Judith took his sword, cut off his head, and gave it to her servant, who hid it in her bags. The two women then stole out of camp and sped home.

Seeing their general's headless corpse, the Assyrians panicked and began to flee. In Bethulia, Holofernes's head inspired Judith's people, who stormed out of the city and routed the enemy, slaughtering many.

The Babylonian Captivity

Exiled to Babylonia by Nebuchadnezzar the Great, the Hebrews lived in what is known as the Babylonian Captivity on the banks of the Euphrates for seventy years. One of the most famous Psalms (Number 136 or 137, depending on the numbering system) sings of the exiles lamentations "By the rivers of Babylon." Here are its famous lines:

> If I forget you, O Jerusalem,
> Let my right hand wither!
> Let my tongue cling to the roof of my mouth,
> If I do not remember you,
> If I do not set Jerusalem above my highest joy.

Scenes of exile, or elegant autumnal landscapes peopled with melancholy figures: the evocative power of this single Psalm has given rise to highly diverse works, always melancholy.

Eduard Bendemann
1811–1889

The Babylonian Exile

Kunsthalle
Düsseldorf
Germany

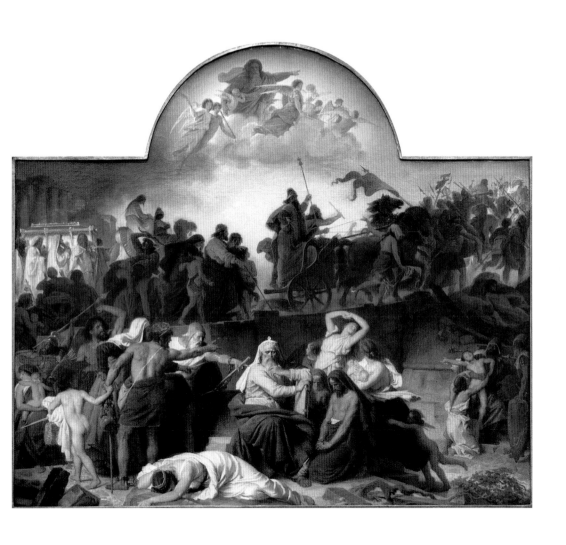

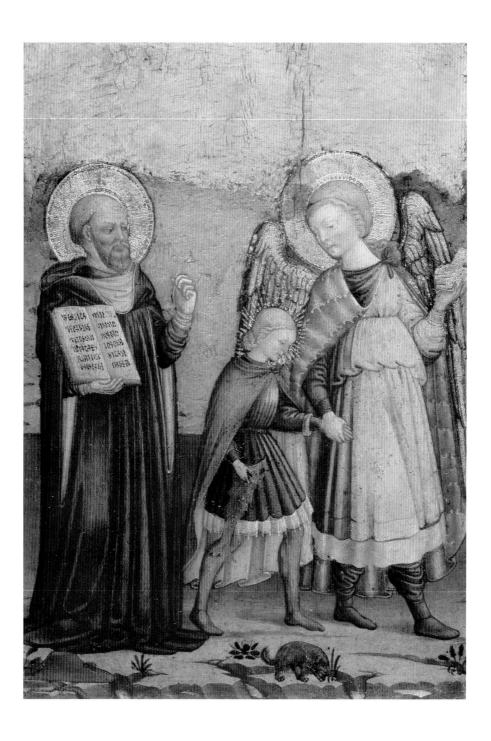

Tobias and the Angel

Neri di Bicci
1418–1492

*Tobias and the Angel with
St. Jerome*

Museo Horne
Florence
Italy

Tobias was the son of Tobit, a respected member of the Jewish community in exile in Nineveh. Sorrow struck the family when the father, sleeping in the shade of a wall, was struck on the eyes by bird droppings and blinded.

Hoping for death and wanting, therefore, to put his affairs in order, he sent Tobias to collect a debt of ten talents of silver from his relative Gabelus, in the Median city of Rages, beyond Ectaban.

As he needed a servant to go with him, when the young Tobias saw, near his home, a young man of good appearance who said his name was Azarias, that he was looking for work, and knew the road to Rages, Tobias hired him, bade his parents farewell, and set out for Rages with his faithful dog and Azarias.

In reality, the new servant was the angel Raphael, who was to help the young hero through his coming adventures.

In paintings of the journey, Raphael, the epitome of the guardian angel, is sometimes depicted as an angel, with halo and wings, and sometimes as a simple page going along with his young master and the dog. In some paintings, they are accompanied by St. Jerome, who translated the Book of Tobit into Latin.

Tobias and Sarah

On the first night of their journey, Tobias and the angel stopped by the Tigris and Tobias went into the river to wash. Suddenly a giant fish surfaced, its mouth agape to swallow the boy up. Raphael heard his cries and called out, "Catch hold of the fish and hang on to it." When Tobias got it up on the bank, Raphael said, "Cut open the fish and take out its gall, heart, and liver. Keep them … for [they] are useful as medicine."

In Ectaban they stayed with a relative of Tobias's father named Raguel, whose only daughter, Sarah, was under a strange curse. Raguel had given her in wedlock seven times, and when each of her seven bridegrooms entered the nuptial chamber, the demon Asmodeus struck them down dead.

Nonetheless, on Raphael's advice, Tobias asked for Sarah's hand in marriage. Raguel gladly agreed, but had a tomb made ready for him just in case.

In the bridal chamber, the young husband Tobias burned the fish's heart and liver, which so repelled the demon that he fled to Upper Egypt, where Raphael bound him hand and foot.

Still following the angel's counsel, Tobias told Sarah that they had to pray to God before consummating their marriage. According to the Vulgate, that is, St. Jerome's Latin version of the Bible, the praying lasted three days.

This defense of abstinence before marriage (even if it is St. Jerome's addition to the story) explains the importance the Church puts on this episode of Tobias's story.

Eustache Le Sueur
1616–1655

Tobias and Sarah's Wedding Night

Louvre
Paris

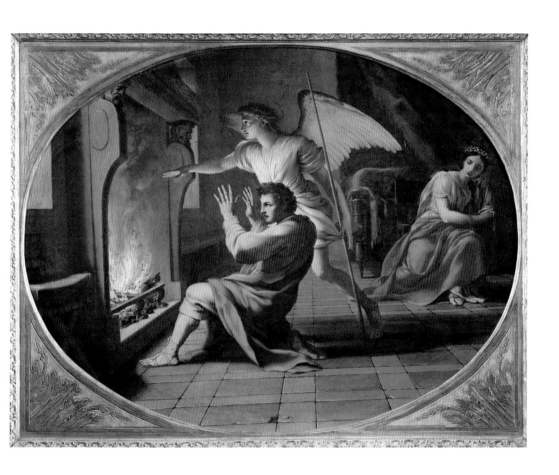

Tobias Heals his Father

Still both serving Tobias and concealing his true identity, Raphael went alone to Rages to remind Gabelus of his debt to Tobias's father and to invite him to Tobias and Sarah's wedding celebration.

Gabelus came with the six talents he owed. At the end of the fourteen-day feast, Tobias wanted to go home. Sarah's parents urged him to stay longer. But the thought of his parents at home was stronger, and he left with his wife and her considerable dowry.

Near Nineveh, he made Sarah and her retinue wait. Accompanied only by Raphael and his dog, he went on to greet his parents. When his old blind father stumbled out of the house, Tobias placed the fish's gall on his eyelids "and the scales fell from his eyes."

Then Sarah produced her dowry and servants and everyone rejoiced. Tobias offered Azarias half of what he had gained on his travels, upon which Azarias said, "I am Raphael, one of the seven angels who stand ready and enter before the glory of the Lord."

Among the moments treated by painters for the edification of the faithful are the healing of the father, the arrival of the bride's caravan, the angel's revelation, and his ascension to his heavenly throne.

Although in the Scriptures Tobias heals his father alone, Annibale Carracci has brought Sarah into the scene to assist him by gently holding the old man while Tobias carefully puts the ointment on his eyelids. Thus the painter adds the moving sub-theme of the specific tenderness and compassion in this first meeting of a father-in-law and daughter-in-law. The scene's overall sweetness is enhanced by the delicate way Tobias holds the ointment vial in his left hand.

Annibale Carracci
1560–1609

The Young Tobias Heals his Blind Father

Staatliche Museen Kassel
Kassel
Germany

Esther and Mordecai

The story of Esther takes place during the reign of Xerxes, whom the Bible calls Ahasuerus.

During the captivity, King Ahasuerus rejected his wife Vashti and sought another queen. His servants had maidens from all over his empire file past him in his harem in Susa.

Among the Jews living in exile at Susa was a young woman of great beauty named Esther, who lived with her uncle Mordecai. She outshone all the maidens brought before Ahasuerus and became his queen.

Biblical interpreters point out that "Vashti," in Perse, signifies "winter," and "Esther," derived from the name of the goddess Ishtar, signifies "spring," and that the name "Mordecai" recalls the Babylonian god Mardouk, and that the name of the Jewish holiday based on this story, "Purim," refers to the Feast of Lots, the Perse celebration of New Year's, which in their empire comes in the spring. But the Bible story only alludes to this possible pagan meaning, and limits itself to the simple telling of the story.

Esther concealed the fact that she was Jewish from both the king and his court, as advised by Mordecai, who stayed in contact with her after she went to live at the palace, which enabled him to use Esther as an intermediary for getting a message to the king concerning a plot against his life.

Filippino Lippi's painting here, depicts a key moment between Esther and Ahasuerus. But, true to its title, *The Story* [or *The History*] *of Esther*, its background details express crises yet to come, including the king's discovery of Haman in Esther's bedchamber and the execution of Haman on the high gallows he had built for the execution of Mordecai.

Filippino Lippi
c. 1457–1504

The Story of Esther

Louvre
Paris

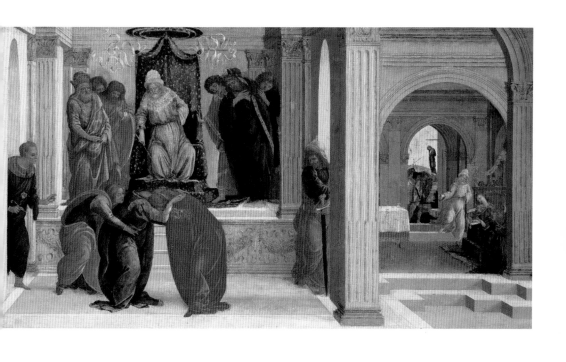

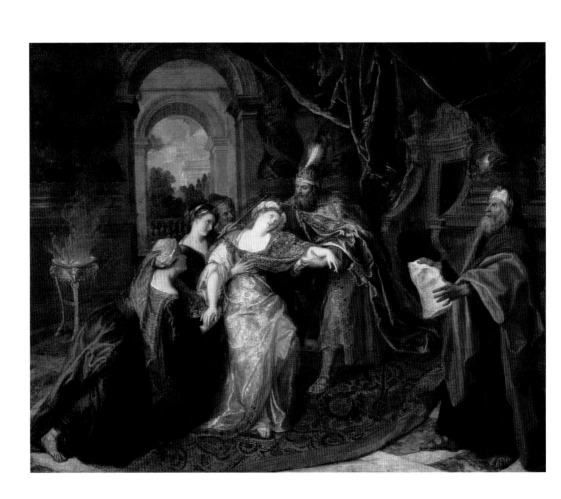

Esther and Ahasuerus

Antoine Coypel
1661–1722

*Esther Swooning
before Ahasuerus*

Louvre
Paris

Haman, the grand vizier of Ahasuerus, king of kings, decided to kill all the Jews of his master's empire. As he explained to Ahasuerus, "There is a certain people scattered and separated among all the peoples in all the provinces of your kingdom; their laws are different from those of every other people, and they do not keep the king's laws."

Ahasuerus gave him carte blanche. To check this murderous program, Mordecai urged Esther to go to the king, even though it was upon pain of death that anyone entered the royal presence uninvited. Terrified, the queen dressed herself in all her royal finery and walked boldly to the king's chamber accompanied by two servants, and waited until he called her to him.

He asked her why she had come and, moved by her beauty, promised her whatever she would ask for even if it should be half his kingdom. She asked only that he would do her the honor to come with Haman to a banquet she was preparing.

It was during this feast that she revealed her true wish: to save the lives of the Jewish people—a wish the king speedily granted.

In the apocryphal Esther with Additions, Esther's first interview with her royal husband does not go as smoothly as in the canonical text. "Lifting his face, flushed with splendor, he looked at her in fierce anger. The queen faltered, and turned pale and faint, and collapsed on the head of the maid who went in front of her. Then God changed the spirit of the king to gentleness, and in alarm he sprang from his throne and took her in his arms until she came to herself. He comforted her," and, hearing her request, granted it. It is this dramatic, emotional account that moved Christian Europe and inspired painters in the seventeenth and eighteenth centuries.

The Disgrace of Haman

During her banquet for Ahasuerus, Esther accused the grand vizier, Haman, of having fomented a plot against the Jews, unbeknownst to the king. Furious, Ahasuerus went out into the gardens to calm himself.

Realizing his disgrace, Haman threw himself down on the foot of Esther's bed and begged her mercy. The king came back inside, saw him there, became angry, and without waiting or indeed asking for an explanation, cried, "Will he even assault the queen in my presence, in my house?"

"As the words left his mouth," the Scriptures continued, "they covered Haman's face," an Old Testament formula meaning Haman's shame was complete.

And when Ahasuerus learned that Haman had prepared a scaffold over sixty feet high for the hanging of Mordecai, he said, "Hang him on that." So Haman was hanged on his own gallows.

Rembrandt
(Rembrandt van Rijn)
1606–1669

Haman in Disgrace

Hermitage
St. Petersburg
Russia

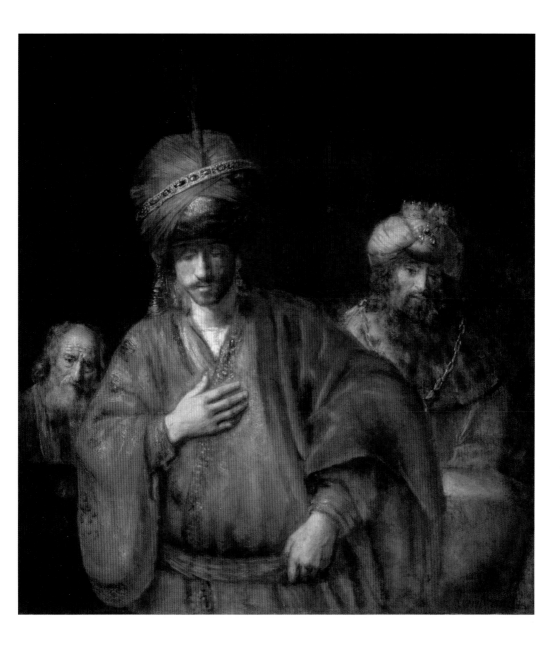

The Triumph of Mordecai

The king remembered that Mordecai had uncovered a plot against him, and, when Esther revealed to him that the old man was her uncle, Mordecai's triumph was complete. Ahasuerus took the ring with which he had elevated Haman and gave it to Mordecai, who became the vizier in Haman's place.

As soon as he was in power, Mordecai sent couriers to the empire's 127 provincial governors from India to Ethiopia with messages annulling Haman's orders to massacre the Jews.

The decree, sealed with the royal signet ring, went much further: it authorized the Jews to attack their enemies. The reprisals began in Susa, where the Jews killed five hundred people, including Haman's ten sons. The movement spread to the provinces and seventy-five thousand people were killed.

Arent de Gelder
1645–1727

King Ahasuerus Honoring Mordecai

Statens Museum for Kunst
Copenhagen

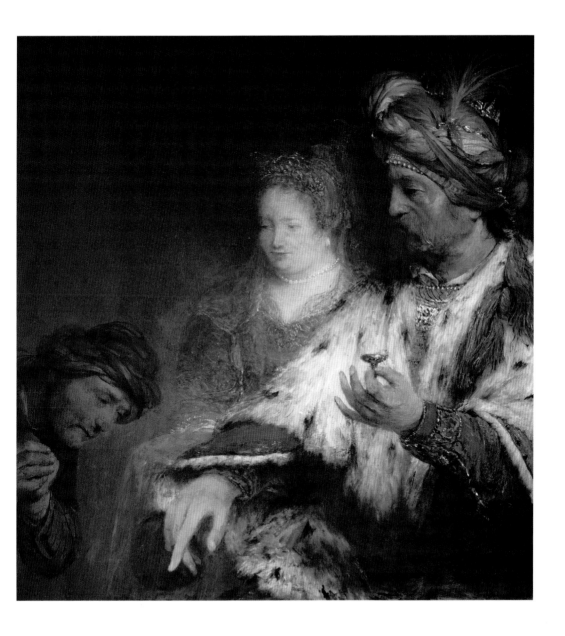

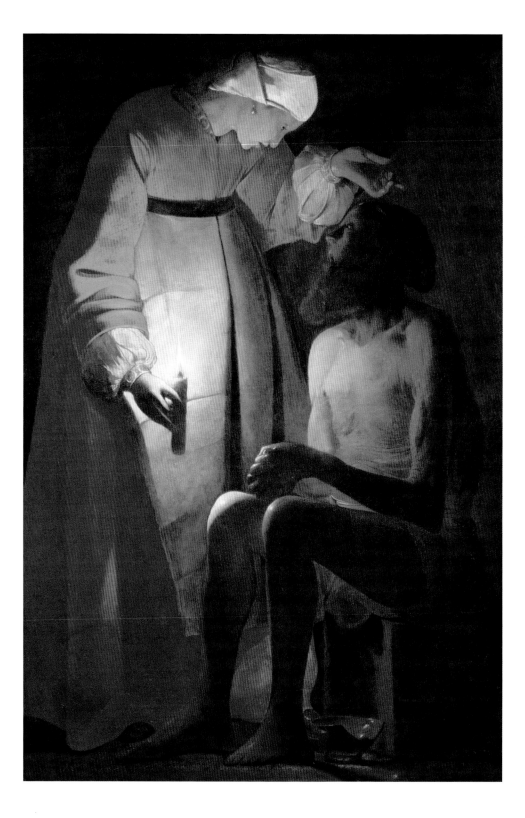

Job

Georges de la Tour
1593–1653

Job and his Wife

Musée Départemental
des Vosges
Épinal
France

In the land of Hus, south of the Dead Sea, lived Job, an upright man who feared God, and the Almighty congratulated himself on the piety of his servant.

When Satan remarked to God that Job scarcely deserved praise, seeing that providence had showered him with prosperity, God agreed to let Satan put his servant to the test.

Blow after blow, by war, rape, or accident, Job lost his five hundred pair of cattle, his seven thousand sheep, his three thousand camels, and at last his seven sons and his three daughters. He himself was afflicted with evil boils from head to foot, and in the end, "poor like Job," was reduced to sitting on a dung hill, scratching his sores with a piece of broken glass.

However, not a word against the Almighty came from his mouth. Exasperated by so much piety, his wife herself reproached him. "Do you still persist in your integrity? Curse God," she said, "and die."

Job was mocked by the people but never renounced God.

In Christian tradition, the mocking of Job prefigures the mocking of Christ. It is in this prophetic perspective that he is often depicted, as much railed at by his wife as the butt of mockeries from a carnival procession. Georges de la Tour, however, has imagined a gentler scene between Job and his wife. Although her face is stern, and Job is slightly stunned by it, her eyes are beseeching and his face seems to express a need for compassion. The gesture of the wife's left hand is ambiguous; it could be a gesture of rebuke or the prelude to a reluctant caress. Candlelight softens the depiction of Job's sores and indeed softens the whole complex scene of subtly conflicting emotions.

Job's Comforters

Three of Job's friends came to comfort him, but the sight of so many miseries kept them silent for the first seven days and nights. Then, giving voice to the commonplace wisdom of the day, they tried to convince Job that, in some way or other, he must have invoked divine punishment.

A fourth person enters the story to reproach Job, but, unlike the first three, says nothing about any offense he might have committed. Instead, he upbraids him for the very fact that he is questioning God's actions and calling himself blameless. No one, he says, can see so deeply into the Almighty that he can judge his actions or criticize his plans.

In the end, God himself speaks to Job of the marvels of creation. The poor man then becomes aware that he has not shown correct resignation with respect to the test to which he has been subjected. Satisfied with this repentance, God re-establishes his prosperity twice over, and bestows upon Job a hundred fifty more years of life for the peaceful enjoyment of it.

Ilya Repin
1844–1930

Job and his Companions

Russian Museum
St. Petersburg
Russia

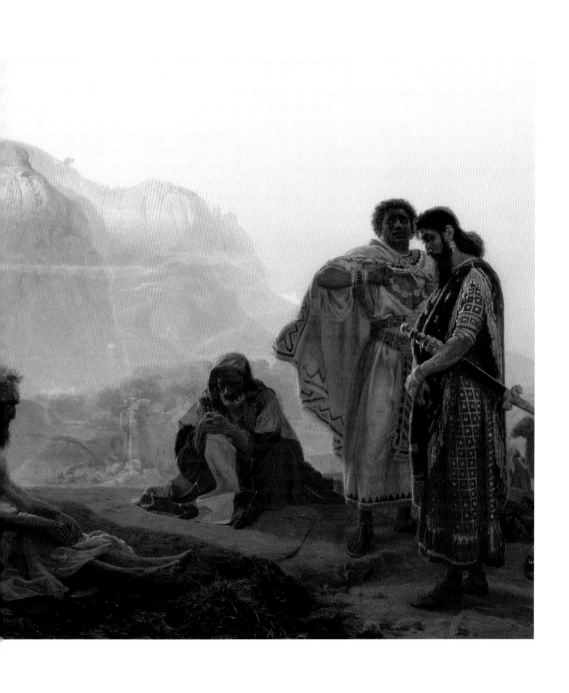

Ezekiel's Vision

At the end of the sixth century B.C., on the banks of the Mesopotamian River Charobas, during the Babylonian captivity, Ezekiel, a Levite in exile, had a vision that turned him into a prophet.

A divine chariot appeared in the clouds, "and seated above the likeness of a throne was something that seemed like a human form," which was the glory of God himself. Beside the chariot were four living creatures, each with four faces: the face of a man, of an eagle, of a lion, and of a bull. These four symbols became allegories of the four Evangelists: the eagle for John, the lion for Mark, the bull for Luke, and a young man for Matthew.

Ezekiel prophesied not only the end of the captivity and the return to Jerusalem but also the reign of the Messiah and the calling of the gentiles. Moreover, he inspired the Apocalypse of St. John. Christian iconography has given him a notable place.

Raphael
(Raffaello Santi or Sanzio)
1483–1520

The Vision of Ezekiel

Palazzo Pitti
Florence
Italy

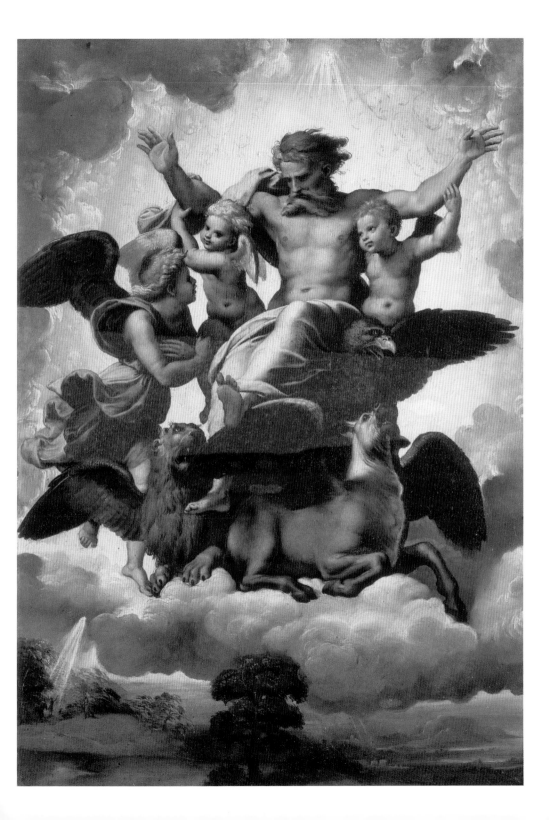

The Fiery Furnace

William Blake
1757–1827

*Nebuchadnezzar
(1795, Allusion to the Madness
of King George)*

Minneapolis Institute of Arts
Minneapolis
USA

Idolatrous princes were given to the calamitous folly of wishing to be worshipped as gods. Having captured Jerusalem and taken its population into captivity, the Syrian Nebuchadnezzar had a golden statue raised to himself and ordered all his subjects to worship it.

Three young Hebrew exiles living in Babylon, Shadrach, Meshach, and Abednego, categorically refused to bow down before any God but theirs. The furious king sentenced them to be thrown living into a fiery furnace, and so great was his anger that he made the furnace seven times hotter than necessary.

The only victims, however, were the executioners, who, when throwing the condemned youths into the fire, were themselves burned, and perished. God's faithful three could not be burned. The king came in person to take them out of the furnace in order to see for himself that neither their skin, nor their hair, nor their clothes had been touched. "I didn't even smell smoke on them," he said.

Nebuchadnezzar later became mad and wandered the countryside for seven years, eating grass like the cattle. When he was cured, he returned to the throne as though nothing had happened.

To early Christian martyrs awaiting death for refusing to sacrifice to the emperor, Shadrach, Meshach, and Abednego were role models and gave hope. Hence their importance to artists at the beginning of the Christian era.

Belshazzar's Feast

During a banquet for his wives and courtesans, King Belshazzar served wine in gold and silver drinking vessels that his father, Nebuchadnezzar, had pillaged from the Jerusalem Temple.

Suddenly the guests saw a hand, writing on the palace walls. Inscribed there in a peculiar script were three mysterious words: "Mene, Mene," "Tekel," and "Parsin."

None of the empire's wise men could interpret them, so the Hebrew prophet Daniel, famous for his wisdom, was called in.

"This," Daniel said, "is the interpretation of the matter: Mene, God has numbered the days of your kingdom and brought it to an end; Tekel, you have been weighed on the scales and found wanting; Peres [Parsin], your kingdom is divided and given to the Medes and Persians."

That night, Darius the Mede (historically, Cyrus the Persian, in A.D. 538) took Babylon.

The story is told in the American country Gospel song *Belshazah*:

Belshazah tried but couldn't find
A man who could give him peace of mind;
But Daniel the prophet, a man of God,
He saw the writing on the wall in blood;
Belshazah asked him what it said,
And Daniel turned to the wall and said,
"My friend, you have been weighed in the balance and found wanting."

Fate inviting itself to the banquet and an orgy turning into terror are dramatic themes that have been taken up by painters many times.

Pietro Dandini
1646–1712

Belshazzar's Feast

Pushkin Museum
of Fine Arts
Moscow

Daniel in the Lions' Den

Andrea Schiavone
(Andrea Meldolla)
c. 1510–1563

Daniel in the Lions' Den

Archiv für Kunst und
Geschichte
Berlin

After he conquered Babylon, one of Darius's first acts was to affirm his own divinity and proclaim a three-month ban on prayers to any god but himself.

Observed while praying to God, Daniel was thrown into a den of lions. Darius, who had previously made him one of his ministers and showed a great liking for him, said only, "May your God, whom you faithfully serve, deliver you!"

After a sleepless night Darius went to the lions' den and was delighted to find Daniel alive and unharmed. He had him brought out of the den and those who had denounced him thrown in. "Before they reached the bottom of the den," the Scriptures say, "the lions overpowered them and broke all their bones in pieces."

Brought up with memories of the persecutions of the Church's early days, Christians can hear familiar echoes of them in the story of Daniel. One thinks of St. Blandine, martyred at Lyon and whom the lions refused to touch.

Susanna and the Elders

Somewhere in Babylonia during the Jewish people's captivity, two lecherous old magistrates chanced to observe Susanna, the wife of the Hebrew Joachim, bathing naked in her garden. Overwhelmed by her beauty and their lust, they accosted her and gave her an ultimatum. "Lie with us," or be charged with adultery. The chaste Susanna replied, "I choose not to … . I will fall into your hands, rather than sin in the sight of the Lord."

The old men publicly asserted that they had seen her beneath a tree making love to a young man and she was summarily sentenced to be stoned to death.

Before the sentence could be carried out, the prophet Daniel, believing Susanna, brought suit against her accusers. At their trial he had them separated so as to prevent them from consulting with each other and insisted that each be examined out of the other's hearing.

To his question, "Under which tree did you see her?" the first said a mastic tree and the second an evergreen oak (some versions say acacia and cypress). Their lie having been exposed, they were stoned to death instead of Susanna.

Susanna at her bath, naked beneath the old men's spying eyes, is one of the most popular Old Testament themes of European painting from the fifteenth through the nineteenth century.

Lorenzo Lotto
c. 1480–1556

Susanna and the Elders

Uffizi
Florence
Italy

Jonah and the Whale

Giovanni da Udine
(Giovanni Nanni or
dei Ricamatori)
1487–1564

Jonah

Münzkabinett
Dresden
Germany

God told Jonah, "Go at once to Nineveh, that great city, and cry out against it; for their wickedness has come up before me."

To avoid so dangerous a mission, Jonah boarded a ship for Tarsis (today's Cadiz; in other words, to the ends of the earth). A storm arose and Jonah, believing himself its cause, asked to be thrown into the sea. After trying vainly to row to shore, the sailors threw him overboard. The storm stopped, the sea became calm, and an enormous fish, which tradition has made a whale, rose up and swallowed Jonah.

In the whale's belly Jonah sang hymns to God night and day. After three days the whale spat him out onto the shore. Then God reminded Jonah of his mission, and this time Jonah set out for Nineveh despite his misgivings.

When Jonah shouted God's curses to Nineveh's people he was so convincing that the whole population repented, from the king on down, and covered the livestock with sackcloth so that they might "cry miserably to the Lord."

When God pardoned Nineveh, Jonah was furious at having run so many risks and in the end not seen the city destroyed. He left for the desert, grumbling.

When he stopped for the day, God made a bush grow over his head to shield him from the sun. The next morning the bush was dry and leafless. Again Jonah grumbled to God, who replied, "You are concerned about the bush, for which you did not labor … it came into being … and perished in a night. And should I not be concerned about Nineveh … in which there are more than one hundred twenty thousand persons … and also many animals?"

Heliodorus Chased from the Temple

This event occurred in 176 B.C., under the reign of the Seleucide dynasty, which, after Alexander the Great's death, was given the eastern half of his empire.

In this year, King Seleucus Philpator wanted to seize the treasure stored up in the Temple of Jerusalem, and sent his legate, Heliodorus, to the Holy City.

The high priest of the Temple explained to Heliodorus that the treasures were either set aside for widows and orphans or belonged to important personages, and that in any case there was less treasure than was commonly thought.

The disciplined agent of his sovereign replied that he would go to the Temple himself and make an estimate.

An infidel in the holy of holies? The city was in an uproar.

But when Heliodorus was approaching the treasure a horseman in golden armor, riding a horse covered with splendid harnessing rushed at him. At the same time, "two remarkably strong, gloriously beautiful, and splendidly dressed young men" appeared at his sides and began to cover him with blows. They took him out on a stretcher, whereupon the high priest conducted a sacrifice for his recovery, which was complete, for he converted to a belief in the true God.

Francesco Solimena
1657–1747

The Expulsion of Heliodorus from the Temple

Louvre
Paris

Major and Minor Prophets

Some churches have pictures representing a cardinal named Habakkuk or a monk named Sophonie, or portraits of a noble old man titled simply Malachi.

These are prophets, each having his own book in the Old Testament, but paintings of them from every Christian epoch depict them in ecclesiastical garments appropriate for an emphasis on their authority and the respect due them.

They are not visionaries who foretold the future but orators who called Israel to the observance of divine law, and who were occasionally able to proclaim good or bad news either for the chosen people or for their enemies.

There are four major Old Testament prophets: Isaiah, Jeremiah, Ezekiel, and Daniel (with Baruch, his companion). After these come twelve minor prophets: Hosea, Joel, Amos, Obadiah, Micah, Jonah, Nahum, Habakkuk, Zephaniah, Haggai, Zachariah, and Malachi.

Each has his own style and themes, reflecting the literary styles and moral and political concerns of his era. However, except for Daniel and Jonah, with their sustained narratives and dramatic events, which lend themselves readily to pictorial representation, the prophetic books of the Old Testament have given rise far less to representations of the prophecies themselves than to portrait representations of the individual prophets, depicted as men of the painter's own times.

Jan van Eyck
c. 1395–1441

The Prophet Zachariah (top)
The Prophet Micah (bottom)

Kathedraal St. Bavo
Ghent
Belgium

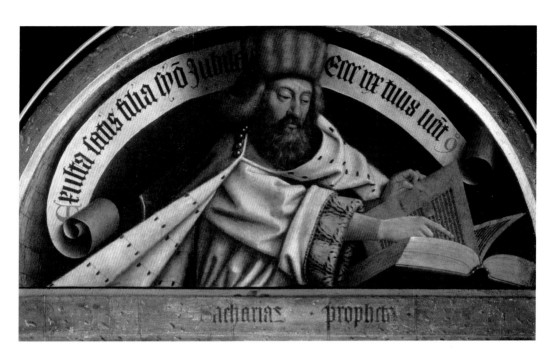

Exulta satis filia syō Judae · Ecce rex tuus venit ·

Zacharias · propheta ·

Ex te egredietur qui sit dominator in ifrl·

Micheas · propheta

First published in English in 2004 by
Merrell Publishers Limited

Head office
42 Southwark Street
London SE1 1UN

New York office
49 West 24th Street, 8th floor
New York, NY 10010

www.merrellpublishers.com

Publisher Hugh Merrell
Editorial Director Julian Honer
US Director Joan Brookbank
Sales and Marketing Director Emilie Amos
Sales and Marketing Executive Emily Sanders
Managing Editor Anthea Snow
Editor Sam Wythe
Design Manager Nicola Bailey
Production Manager Michelle Draycott
Design and Production Assistant Matt Packer

English-language edition copyright © 2004 Merrell Publishers Limited

First published as *l'Ancien Testament à travers 100 chefs-d'œuvre de la peinture*
in 2003 by Éditions des Presses de la Renaissance
12 avenue d'Italie, 75013 Paris
Copyright © 2003 Presses de la Renaissance, Paris

British Library Cataloging-in-Publication Data:
Debray, Regis, 1941–
The Old Testament through 100 masterpieces of art
1.Bible. O.T. – History of Biblical events – Art
2.Painting, European 3.Christian art and symbolism
I.Title
755.4

ISBN 1 85894 261 6

Translated, adapted, and augmented by Benjamin Lifson

Produced by Merrell Publishers Limited
Designed by Nicola Bailey
Copy-edited by Richard Dawes

Printed and bound in China

This book was published with the support of the French Ministry
of Culture's National Center for the Book.

Photographic Credits

AKG Paris
The British Library / AKG Paris
Cameraphoto / AKG Paris
Erich Lessing / AKG Paris
Joseph Martin / AKG Paris
Pirozzi / AKG Paris
Rebatti – Domingie /
AKG Paris
VISIOARS / AKG Paris

NOTE ON THE IMAGES
Some of the reproductions in this
book are cropped versions of the
original paintings.

JACKET FRONT
Cavaliere d'Arpino
(Giuseppe Cesari)
The Expulsion from Paradise
see page 31

JACKET BACK
Domenico Fetti
Jacob's Dream of the Ladder
to Heaven
see page 63